BOLD EXPRESSIVE *painting*

Painting Techniques
for Still Lifes, Florals and Landscapes
in Mixed Media

Annie O'Brien Gonzales

NORTH LIGHT BOOKS
CINCINNATI, OHIO
www.CreateMixedMedia.com

Contents

Introduction
Paint in a Way That Makes You Happy 4

Painting Materials 6

Hand + Eye + Heart 8

Elements and Principles of Art 10
Elements of Art 10
Principles of Design 12

Chapter 1: Finding Inspiration 14
Technique 1: Inspiration Board 16
Project 1: Painting Notes 18
Technique 2: Learning From Artist Ancestors 20
Technique 3: Art Elements Scheme 22
Technique 4: Incorporating Personal Symbols 24

Chapter 2: Expressive Composition, Color and Value 28
Dynamic Compositions 30
Expressive Color 34
Choosing a Palette 36
Choosing a Color Scheme 40
Technique 5: Two-Value Notan Drawing 42
Technique 6: Three-Value Scale 44
Technique 7: Composition Options 46
Technique 8: Color Mixing Chart—Warm and Cool 48
Technique 9: Color Wheel With Purchased Paint 50
Technique 10: "Go-To" Color Schemes 52
Technique 11: Balancing Color With Neutrals 54
Technique 12: Mixing Creative Greens 56
Project 2: "Go-To" Color Scheme Grid Painting 58
Project 3: Still Life With Creative Green Mixtures 60

Sign up for our free newsletter at www.CreateMixedMedia.com

Contents

Chapter 3: Mixed-Media Painting 64

Technique 13: Gathering Mark-Making Tools 66

Technique 14: Stamps, Stencils and Masks 68

Technique 15: Gelli Plate Printing 72

Technique 16: Creating and Collecting Collage Materials 76

Technique 17: Mixed-Media Underpaintings 84

Project 4: Still-Life Collage Study 88

Project 5: Mixed-Media Still-Life Painting 92

Project 6: Mixed-Media Abstract Oil Painting 96

Project 7: Upcycled Acrylic Painting 104

Chapter 4: Floral Still-Life Painting 106

Setting Up a Floral Still Life 108

Technique 18: Personalizing Still-Life Paintings 109

Technique 19: Adding Texture to Paintings 110

Technique 20: Negative Shape Painting 114

Project 8: Mixed-Media Floral Still-Life Painting 116

Chapter 5: Loose Expressive Landscapes 122

Technique 21: Painting Outside the Landscape Box 124

Technique 22: Glazing a Painting 128

Project 9: Landscape Collage Painting 130

Project 10: Loose Expressive Landscape Painting 134

Final Thoughts 138

Critiquing Your Own Work 139

Inspiration Resources 140

Index 141

About Annie 143

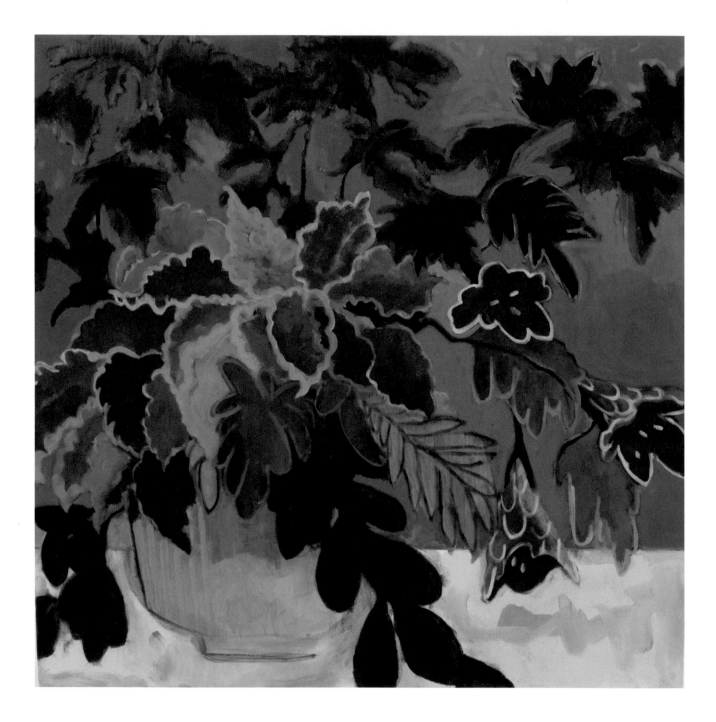

Sign up for our free newsletter at www.CreateMixedMedia.com

PAINT IN A WAY
That Makes You Happy

When I think of expressive painting, I think of the Fauves, Expressionists and Post-Impressionists—painters like Vincent van Gogh, Henri Matisse, Pierre Bonnard and André Derain—painters who decided to use vivid, nonnaturalistic color and composition. They were artists who invented painting in a style that is highly personal and subjective. That's what this book is all about. The basics of painting must still be learned, of course: how to mix colors, compose a picture, use light and dark to attract the eye . . . but beyond the basics the content and style are invented by the painter. Perhaps you have received feedback that keeps you from painting in a way that feels most natural to you. Who knows why, but when I began painting I had it in my head that to be a real painter one had to paint realistically. Then I took a hard look at what truly made me happiest, which artists' work I gravitated to and realized that for me, painting is about color, pattern and expression and less about perfection or meeting the expectations of others.

As painters we owe a debt to those artists who around the turn of the twentieth century experimented with breaking free of long-held painting traditions. Beginning in the late 1800s with the Impressionist painters (Claude Monet, Camille Pissarro) and later the Post-Impressionists (Paul Cezanne, Vincent van Gogh, Paul Gauguin) and the Fauves (Henri Matisse, André Derain), painters began to celebrate pattern and color and abandon techniques such as the mathematical principles of linear perspective. They experimented with expressing emotions through heavily textured surfaces, bold brushstrokes and vivid color. The legacy of such movements is that we now have the autonomy to paint with individualism and originality. We only have to please ourselves.

PAINTING *Materials*

This list is a guide to what will be needed for the techniques and projects in this book, but it is not intended to serve as a "must" list of supplies. Feel free to substitute what you have available in your studio and buy only what you need in small quantities to begin.

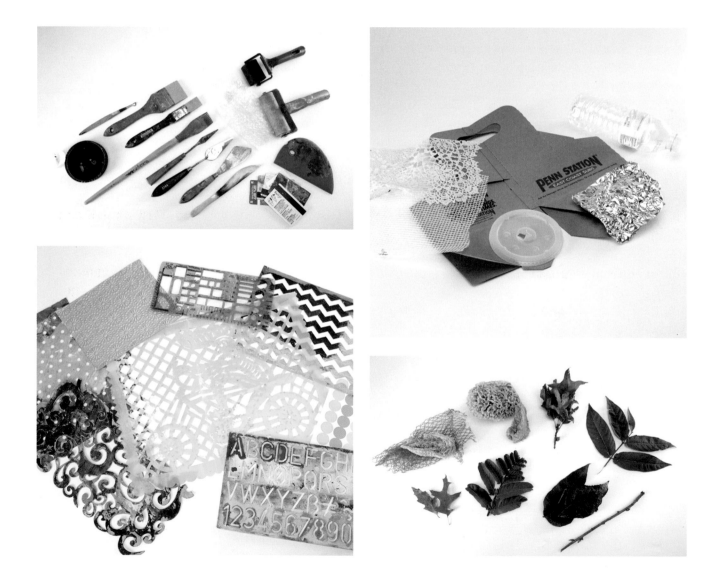

Sign up for our free newsletter at www.CreateMixedMedia.com

Acrylic Mediums
acrylic glazing liquid, fluid matte medium, soft gel matte medium

Acrylic Paints
fluid and heavy body; primary and secondary colors plus black and white

Acrylic Specialty Mediums (try one or two)
clear tar gel, glass bead gel, molding paste, pumice gel

Alkyd Resin Medium (Galkyd)

Art Tissue (Spectra Deluxe)

Deli Paper or Dry Wax Paper (Dixie Kabnet)

Gelli Arts Printing Plate

Mineral Spirits, Odorless (Gamsol)

Oil Paints
primary and secondary colors, plus black and white

Oil Sticks or Oil Pastels

Paintbrushes
inexpensive synthetic or bristle brushes, ½" (13mm), 1" (25mm), 2" (51mm); bright or flat shape

Palette Knife

Paper Palette Sheets (Gray)

Permanent Writing Pens
Pigma Micron pens .05 or your favorite

Powdered Pigments

Rubber Brayer (Speedball)
4" (10cm) soft

Sketchbook, Spiral 8½" × 11" (22cm × 28cm)

Substrates
assortment of sizes of canvases and/or panels: gessobord, hardboard or inexpensive student-grade canvas boards (See specific projects and techniques for recommended sizes.)

Wax Medium (Gamblin)
cold wax medium

White Gesso

Hand + EYE + Heart

In *A Bigger Message: Conversations with David Hockney* by Martin Gayford, renowned British artist David Hockney expressed his belief in the Chinese saying that "you need three things for paintings: the hand, the eye and the heart. Two won't do. A good eye and heart is not enough; neither is a good hand and eye." We can translate "hand, eye and heart" to mean skill, vision and passion—the ingredients necessary to develop as a painter and to find your own unique style.

Hand - Skill

Let's talk about the "hand" or skill part of the equation first. Picture yourself learning to play classical guitar. Would a practice session once a month get you to a concert hall or even competently playing for a group of friends? No way. What is necessary to gain the skills needed to be a competent painter is what writers call the "no excuses—butt in chair" approach. Painters must make a "no excuses—time at the easel" commitment. There is no other way, no magic book, workshop or mentor that will take you all the way there. These all have a place in learning to be a better painter (I have taken advantage of all of them), but there is no substitute or shortcut for "no excuses—time at the easel."

Developing as a painter takes hard work and lots of hours of actual hands-on painting—not blogging, checking Facebook or organizing supplies. Hands-on painting is the only way.

Eye - Vision

Developing a personal style or vision for your painting is a question on the mind of every artist, myself included. Everyone has asked themselves and their teachers, "How do I develop my own style?" You didn't have to think about developing your own style of handwriting, did you? You learned the basics of penmanship in school as a child; you kept on writing and you developed your own style of handwriting without thinking about it too much. If you decided right now that you wanted to completely change your style of handwriting, you would have to work hard at it. Painting style develops in the same way—with your own signature if you let it. Look to your artist heroes or ancestors to clarify what it is about particular works of art that makes your heart sing. Concentrate on learning the basic language and skills of painting. Be open to experimenting with different mediums and with different subject matter, and you will find what resonates with you. Think about what you want to communicate through painting. If you do all of these things consistently, over time you will have developed your own style or vision. But it won't happen with one class, one book or by imitating someone else's style.

Heart - Passion

Passion or heart is necessary to generate the energy and enthusiasm needed to work hard at painting. You must put what you love—your passion—into your work. The most difficult, frustrating day of painting must still be better to you than anything else you could be doing. You must be confident and bold and not let fear or rejection stop you. Georgia O'Keeffe said, "I've been absolutely terrified every moment of my life and I've never let it keep me from doing a single thing I wanted to do."

Sign up for our free newsletter at www.CreateMixedMedia.com

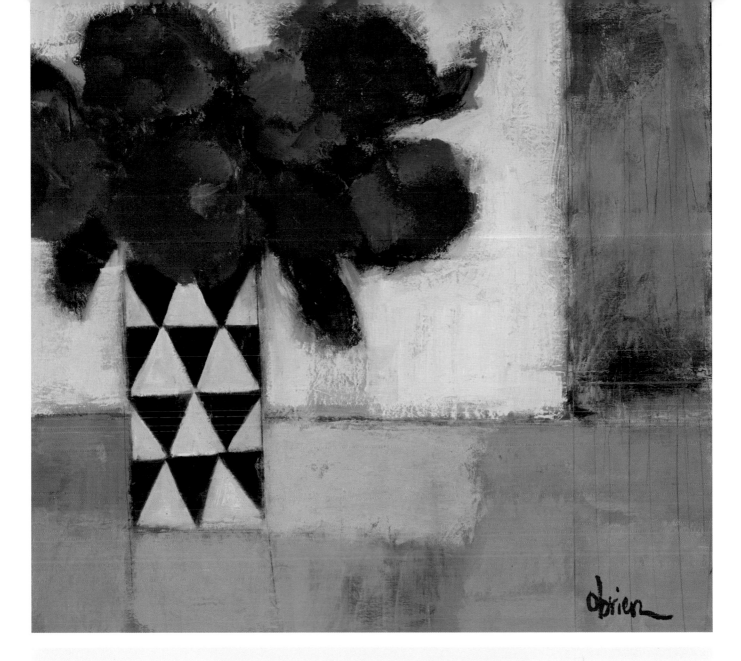

THINGS TO REMEMBER ON THE JOURNEY

- *Create a schedule and paint a lot.*
- *Stop repeating negative messages in your head, now.*
- *Take risks—keep trying something new, look for subject matter that is meaningful to you.*
- *Don't be afraid to show your true colors—literally.*
- *Strive for fresh, not repeating what everyone else is doing.*
- *Paint to your favorite music. Music keeps a certain part of your brain engaged, releases endorphins and creates a sense of rhythm.*
- *Forget the rules you learned in grade school, art school or any school. Art doesn't have rules, only guides.*
- *Decide what emotion you want to convey in each painting and repeat this to yourself as a mantra while you paint.*

- *Try painting faster than you normally would, especially at the beginning.*
- *Don't mentally trash each painting and quit. Critique it, learn at least one thing from it and do another.*
- *Acknowledge that you will be making hundreds of paintings so this one doesn't have to be perfect. Think of each one as practicing "scales" on the piano—you need to do it a lot.*
- *Trust the process; you will learn from each painting, you will improve and you will develop your own style.*

Elements and Principles
OF ART

It's important for every artist to understand the **elements of art** and the **principles of design**. *Oh no*, you're probably thinking, *not art school!* But bear with me; these are really pretty obvious and easy to remember—this is just a quick refresher.

The elements of art and principles of design are basic components of every design and apply to all works of art. Whether you are aware of it or not, you are making decisions about these elements and principles every time you use or don't use them. A basic understanding of the elements of art will allow you to make decisions about what you want to emphasize in your artwork. Read these, put them away for future reference and go on with your work.

Elements of Art

Color

Color is created by the reflection of light and is described by its properties—hue, value and intensity. There are only three **primary colors** of paint pigment—red, yellow and blue—which cannot be created by mixtures of other colors. **Secondary colors** are created by the mixture of two primary colors—orange, green and purple. **Tertiary colors** are a mixture of a primary color with a secondary color—red/orange, orange/yellow, yellow/green, green/blue, blue/purple, purple/red.

Lines

Lines are either marks made by tools or two shapes coming together that have greater length than width. When lines take different paths they can convey different emotions due to the associations our brains automatically put together. For example, a horizontal line suggests a landscape because it represents a horizon, something we've looked at since we became conscious. Horizons give most of us a sense of peace and familiarity. Diagonal lines suggest movement because they are jetting off to somewhere and not parallel to the horizon. Vertical lines give a feeling of height (skylines, right?). When you put horizontals and verticals together, they create solid forms that our brain perceives as stability. Curving lines are the most

sensual because they suggest natural forms including plants, flowers and the curves of the human body.

Shapes

Shapes are enclosed by lines and defined by their edges. Shapes can be either organic and curving such as plants or geometric—squares, rectangles, hexagons, etc.

Space

Positive/negative space refers to the relationship between objects and backgrounds within the two-dimensional space of the painting.

Texture

Texture can be visual or tactile. Tactile texture is created by different brushstrokes such as heavy impasto paint applications, collage or mixed-media techniques such as modern mediums (gesso, pumice, glass beads, etc.). Visual texture is created through the use of pattern within shapes and backgrounds.

Value

Value is the lightness or darkness within a painting.

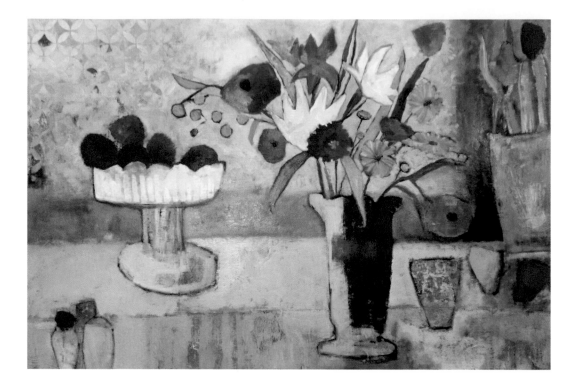

Principles of Design

The principles of design apply to all of art and design and are most useful to painters when planning compositions and critiquing works of art, including their own. The principles of design describe how the elements of art are put into use within a painting and are really a language used by artists, designers, collectors, gallerists and curators—a way of thinking and talking about design and communicating with others.

Balance
Balance is the appearance of equilibrium among the objects, colors and spaces within a design. The terms *symmetrical*, *asymmetrical* and *radial* describe the balance of elements within a design.

Emphasis
Emphasis is created when one element of a design such as a focal point draws the eye to a certain area. Emphasis can also be achieved through contrast, color temperature, value or scale.

Pattern
Pattern applies to the repetition of a symbol or element across the design.

Proportion and Scale
Proportion and scale refer to the relationship of the objects to one another and in reference to reality or norms.

Rhythm and Movement
Rhythm and movement occur when the repetition of shapes, color, pattern or the creation of a path for the eye within a design create movement or a "beat" that suggests motion.

Unity
Unity refers to the sense that elements of a design are working in harmony to create a whole.

OK, that's it. Not too much to think about, right? Post these elements and principles in your studio or workspace and refer to them as you step back and evaluate your own work.

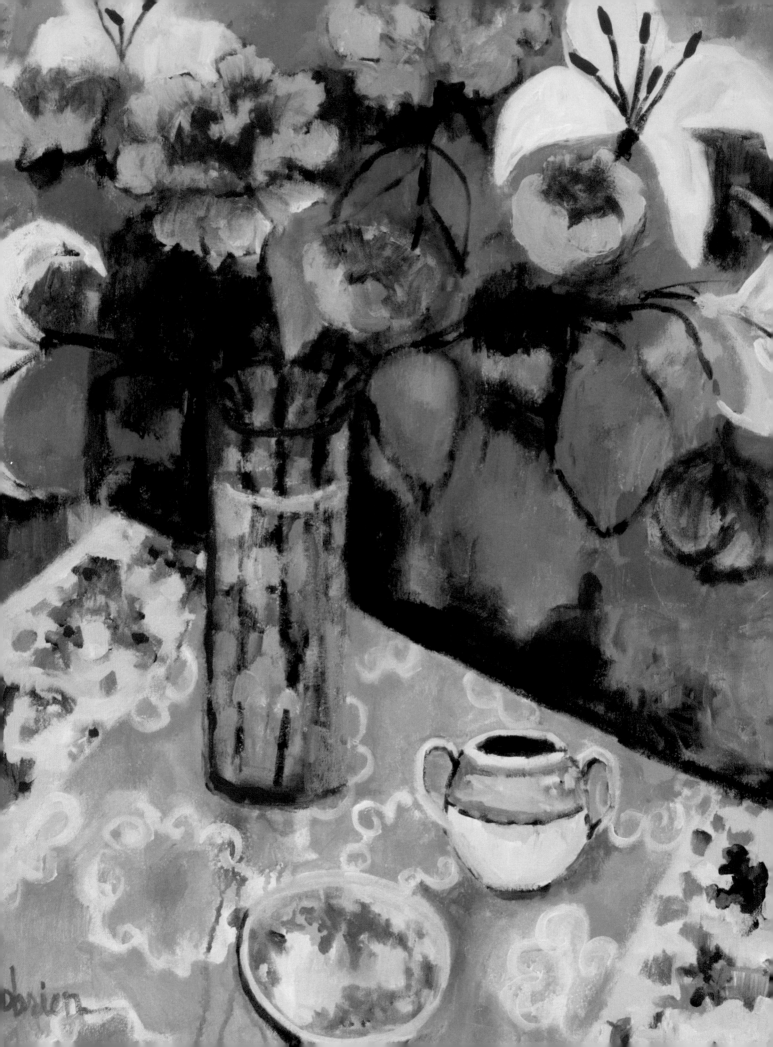

FINDING Inspiration

Inspiration is for amateurs. The rest of us just show up and get to work.

—*Chuck Close*

OK, the first question you might be asking is, *Where am I going to find inspiration for paintings?* Answer: Everywhere! You will find it in museums and galleries, of course, but consider all of the things you encounter as you go about your day. Almost everything around you has an element of interest. The trick is to look with "interested eyes." Creativity is a way of approaching life, not a talent that some are born with and others are not. Creativity can be cultivated and sharpened with practice; but first, you must believe this.

Open your awareness to your own history, talents, interests and fascinations. What do people comment on about your home, the way you dress, the movies you like, the music you listen to, your *style*?

What area of the bookstore pulls you in? What activities bring you true joy—cooking, setting a beautiful table, dressing creatively, hiking,

changing your hair color? Those things will tell you something. Look not just in museums and galleries but check out popular design magazines (home design, gardening, cooking, crafting, etc.) that contain brilliant color schemes and composition ideas created by some of the most talented designers, and start to look through them with an artist's eyes. Take note of display windows, nature, clothing, antiques, music, people in cafes, the sky—there is no limit. The more you exercise your creativity, the more it will grow and reap rewards in your art. Find your art ancestors; which artwork makes your heart sing? Study these artists, learn from them and then make something of your own. This is how it is done. It's not a secret or an inborn talent; it is something anyone can nurture. The following techniques are intended to point you in the direction of awareness and cultivation of your own unique creativity.

What You Need

- corkboard bulletin board (as large as possible)
- pushpins
- things you collect and find that inspire you (paint chips, color schemes, magazine photos, scraps of fabric, postcards, results of technique experiments from this book, etc.)

Inspiration BOARD

Creativity is not a talent—it is a way of operating.

—*John Cleese*

1 Hang your Inspiration Board in your studio or work area so you will see it every day.

2 Begin to collect your inspirations and pin them on your Inspiration Board without thinking about editing—stay in your expressive, creative brain rather than your analytical brain. (Don't judge whether something is worthy of being on the board.)

As artists we respond to and actually require visual stimulation. Inspiration boards are visual references of what excites us at the moment. Pin color swatches of fabric, photos, postcards, clippings out of art magazines and quotes that inspire you to keep creating. Just a note of caution: Keep your to-do list off of your Inspiration Board or you may decide you never want to look at it! Right away, create an Inspiration Board in your studio or work area to provide visual stimulus for your work.

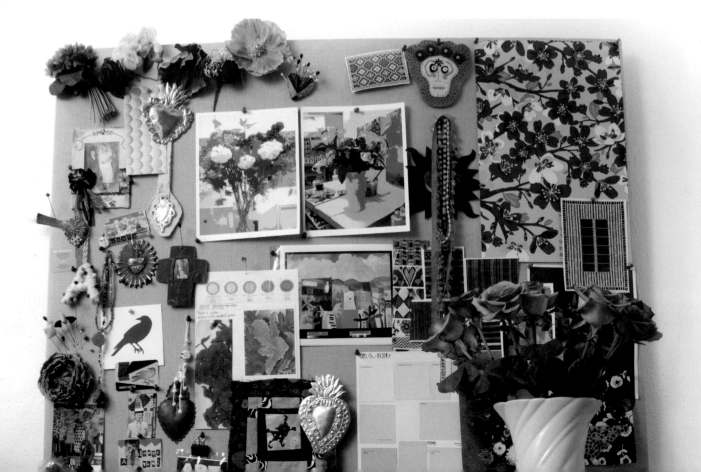

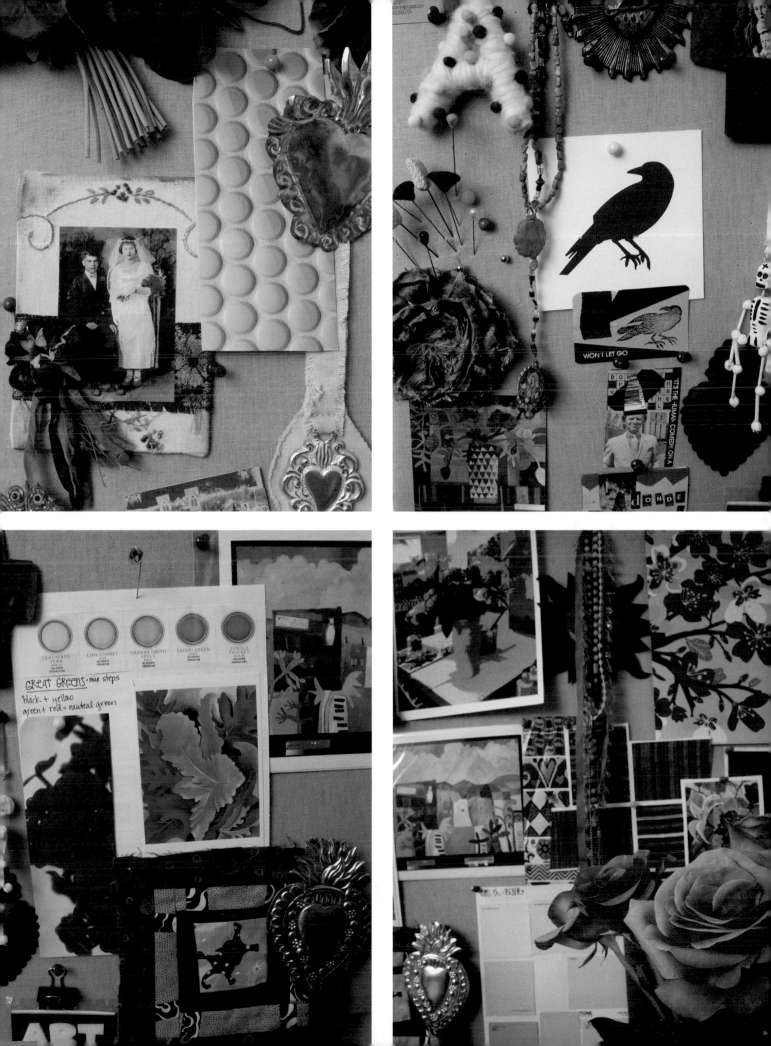

Painting
NOTES

All art is contemporary, if it's alive. And if it's not alive, what's the point of it?

—David Hockney

Keeping track of your ideas, inspirations and plans for paintings is a challenge. Ideas can pop into your head in the strangest places. One method that has worked for me is to train myself to keep track of everything in what I call my "Painting Notes."

There's a big difference between an art journal and a Painting Notes sketchbook. You will see lots of books and websites about art journaling. That is not what a Painting Notes sketchbook is meant to be. It is meant to serve as a living, breathing, working reference stuffed with ideas for paintings. Many art journals are meant to be works of art in themselves. Painting notes don't have to look pretty; they need to serve as your guide along the art path. If you have to stop and think about composition, color, etc. before you create an entry in your Painting Notes sketchbook, it will be too much trouble and will defeat the purpose.

Get in the habit of putting your ideas/samples/ sketches in one place—your Painting Notes sketchbook—as soon as they come to you. When you fill Painting Notes volume one, start on volume two. Start a page in your Painting Notes (maybe in the back) just for an ongoing list of painting names and series ideas. Carry your Painting Notes sketchbook with you to your studio, to workshops, trips to galleries and museums, just about everywhere. Be sure to date your entries and the volume. It's interesting to go back and track your projects and interests over time. Renowned British artist David Hockney even had his suit pockets altered so his books would fit. Take it with you *everywhere*.

What You Need

- ◻ colored pencils, journaling pens, any favorite writing/drawing tools (I love LePens and Pigma Microns)
- ◻ spiral sketchbook, 8½" × 11" (22cm × 28cm) or larger
- ◻ washi or paper tape to paste in clippings from magazines, brochures

TOPIC IDEAS FOR PAINTING NOTES

I advise starting a new page for each category of ideas so when the inspiration hits, you will have plenty of room to jot it down.

- *Your thoughts on techniques and projects in this book*
- *Notes from workshops or lectures, trips to museums, galleries, references you want to track down*
- *Ongoing list of potential painting titles*
- *Ideas for a painting series*
- *Favorite song fragments or lines in poems*
- *Fragments of conversations or advertising slogans you see*
- *Catalogs of shapes, patterns and personal symbols*
- *Photos of color combinations from magazines*
- *References you find inspiring*
- *Subjects, themes, things, places, songs, books that grab you*
- *Photos, scraps of paper, quotes*

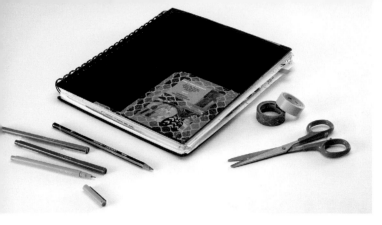

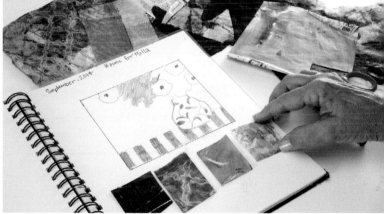

1 Find a sizable spiral sketchbook, label it *Painting Notes, Volume One* and date it somewhere. It should be large enough to really spread your ideas and notes across the page but still fit in your tote bag. Spiral-bound is important so you can comfortably work in it flat. Make sure it's not too expensive—no leather-bound embossed journals for this project.

2 Start an entry with the date and a few notes quickly jotted down about your entry.

4 Tape in photos, magazine clippings, brochures, maps, whatever sets your ideas in motion and supports your ideas.

3 Add small, quickly done sketches with colored pencils, markers or pens to remind yourself of what you might create with this idea. If you are planning a painting, create a sketch of what it might look like.

Add some notes about what you could do with this idea—believe me, this will come in handy when the well of ideas has run dry! Write a little something each day, stick a photo or clipping in your Painting Notes, sketch something quickly.

Start individual pages for some of the topic ideas in the previous list or any other ideas you come up with. Add your notes from workshops or lectures on painting, trips to museums, galleries, references you want to track down.

Record your approaches to the techniques and projects in this book, along with notes about what worked and what didn't for you.

LEARNING FROM
Artist Ancestors

What a good artist understands is that nothing comes from nowhere. All creative work builds on what came before. Nothing is completely original.

—Austin Kleon

Austin Kleon is the author of a great little book called *Steal Like an Artist*. In the book, he reminds us that all artists learn from other artists, pure and simple. The trick is to take what you need and make it your own without merely imitating their work. We all know that people have quite individual tastes in artwork. For example, the work of three very different artists—David Hockney, Henri Matisse and Georgia O'Keeffe—makes my heart race for very different reasons. Yet thousands of other artists, even renowned ones, leave me absolutely cold.

Artists individually resonate with works from a very particular group of artists that I like to call "artist ancestors," and I believe it's useful to think about why. Think back; whose posters adorned your walls in college? When you got that first apartment, whose art did you tack up on your wall or bulletin board? Which art books do you collect? Most of us know intuitively which artists make us swoon. That's an important signal to pay attention to and take the next step.

To learn from the work of an artist ancestor, apply the analytical part of your brain to think about what it is that makes their work so appealing and whether you can apply that to your own work or just admire it from afar.

This is how you develop your own style. When you incorporate elements from your artist ancestors, combine them and take them in your own direction, you are creating your own painting style. All artists are an amalgam of inspiration from other artists and innovations of their own. Once you have analyzed the elements you want to incorporate in your own work, you can move from imitation to innovation using those elements. This technique will assist you to analyze the work of your artist ancestors.

What You Need

- □ double-sided tape
- □ favorite pens
- □ Painting Notes sketchbook
- □ photocopies of your favorite artists' works
- □ scissors

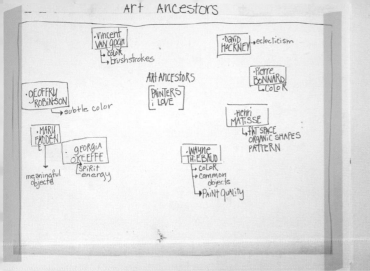

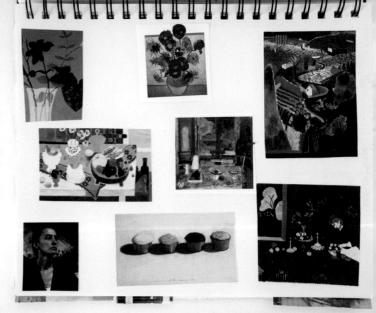

1

On the first page of your brand-new Painting Notes sketchbook, brainstorm a list of artists who consistently grab your attention—living or not; it doesn't matter. Don't think too much, don't question yourself and just write your list of at least five artists.

2

Photocopy or download and print reproductions of your favorite pieces of the artists' works that really make your heart sing and stick them on a page or spread in your Painting Notes sketchbook.

3

Study the pieces for a few minutes and without analyzing, jot down what you find most appealing about the works. What elements do you respond to? Some suggestions of elements might be:

- Use of line or pattern
- Approach to perspective
- Unusual shapes
- Use of texture
- Color palette
- Value contrast
- Subject matter
- Scale
- Composition
- Abstraction vs. realism
- Painting style (Expressionist, Impressionist, etc.)
- Painter's life or approach to their art

Art Elements SCHEME

If only we could pull out our brain and use only our eyes.

—Pablo Picasso

As artists, we are visual learners. That's why an art elements scheme can really help us learn from art ancestors and focus our next steps. The art elements scheme is really what is called a "Concept Map" in learning theory, a visual representation of the bigger picture forming in your mind with art elements you most want to incorporate into your own work. Concept maps enable visual learners to see the big picture or universe of ideas because just a list of terms doesn't really work for us.

Once you have done the artist ancestors exercise in Technique 2, pull the elements that attracted you most into one visual chart (or, as the social media world now calls it, an "infographic") to tie things together and serve as your visual roadmap.

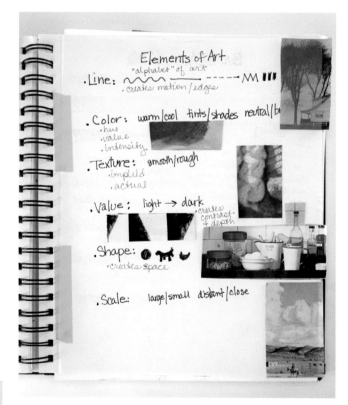

What You Need

- ¤ favorite journaling pens
- ¤ Painting Notes sketchbook with results from Technique 2: Learning From artist ancestors

1 On a single page in your Painting Notes titled Art Elements Scheme, transcribe the elements that attracted you from your top two or three art ancestors. Don't create just a list; create a visual map. Use color, shape, doodling, anything to make it visual and distinctive.

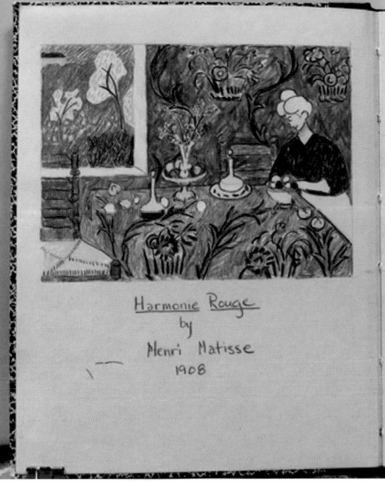

Harmonie Rouge by Henri Matisse 1908

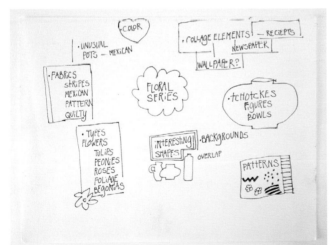

2 Study your art elements scheme and note the elements that were repeated more than once. Take note if you consistently were attracted to certain elements. Do all of your heroes use bold color, for instance? This should tell you that color is one of the chief elements you might want to incorporate into your work.

- Consciously begin to incorporate elements into your own work that you identified as most appealing to you. For instance, if you adore Matisse's use of color, begin to focus on color as a primary element in your work; give it the starring role. You will not be copying Matisse, but you will have identified Matisse's use of color as a major element that resonates with you and something you would like to include in your own work.

- Keep this scheme handy for visual reference as you develop your work. Use it to systematically try out elements that appeal to you and make notes about how they work for you.

- Revisit your art ancestors and art elements scheme and update them periodically to incorporate new inspirations you discover on your path. Create new art elements schemes to try out in your own work. Use these ideas to analyze your own work, referencing the art elements that attract you most.

INCORPORATING
Personal Symbols

The chief enemy of creativity is "good" sense.

—**Pablo Picasso**

Artists have incorporated symbols as a form of communication since cave painting. Symbols can be shapes, colors, icons, almost anything that is endowed with a meaning by human beings. We see symbols all around us, and some resonate with us more than others. We put them on our car, our T-shirts, our furnishings. We are communicating through symbols every day, whether we realize it or not. Why not make conscious choices about the symbols we add to our artwork so they become personal?

One of the best ways to personalize a painting is to begin to incorporate symbols that are meaningful to you. Take note of symbols in your environment—the choices you make every day. Do you constantly choose clothing with stripes or polka dots? Those are symbols for you. What about geometric shapes, labyrinths, arrows; do they show up in your doodles? Those are communication symbols for you. This exercise will encourage you to catalog your personal symbols so you have a ready resource to draw from in your artwork.

What You Need

- colored pencils, journaling pens, any favorite writing/drawing tools
- glue stick or other paste
- magazine clippings, photos
- objects that are meaningful to you or attract your eye
- Painting Notes sketchbook

Quick Tip

Here are a few ideas to get you started thinking of personal symbols: colors, circles, totems, animals, seedpods, stripes, patterns, spirals, microscopic forms, polka dots, pink things, flowers, hearts, birds, letters, spheres, raindrops, letters, eggs, shells, fabric patterns, wallpaper.

Sign up for our free newsletter at www.CreateMixedMedia.com

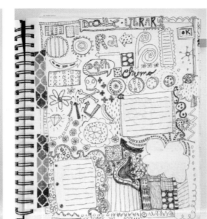

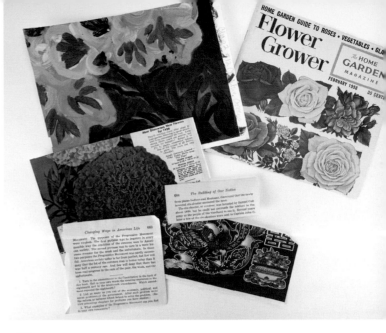

1 In your Painting Notes sketchbook, create pages for shapes, symbols, objects, elements, materials, patterns and colors that attract you.

2 Paste photos from magazines of rooms, designs, paintings, photos and patterns that interest you.

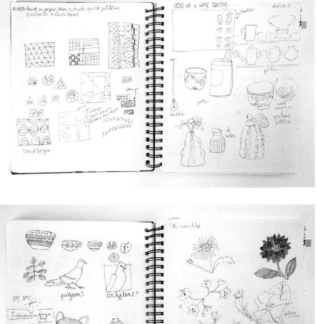

3 Collect items to incorporate into your paintings from your home, thrift shops or studio in one place that is handy for you to choose from.

4 Sketch objects and write down your thoughts about them.

For additional downloads from the book, go to: www.CreateMixedMedia.com/BoldExpressivePainting

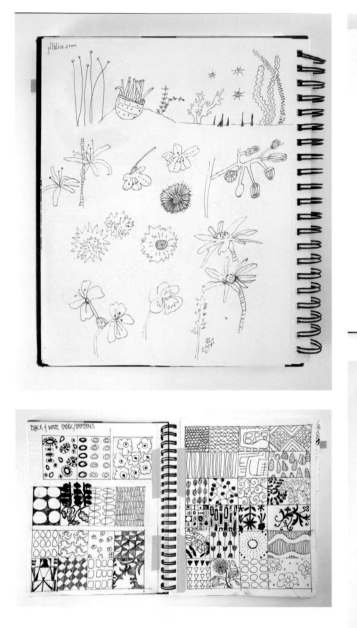

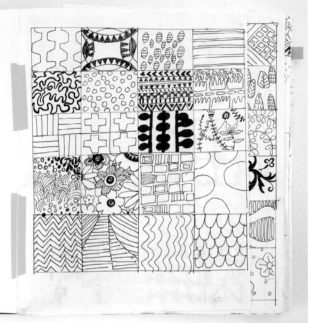

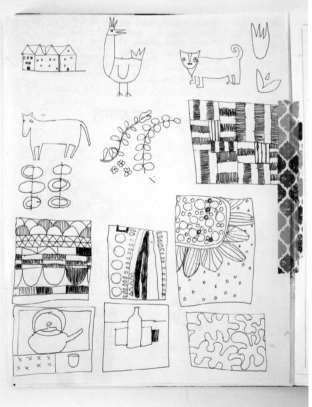

These images from my Painting Notes sketchbook show patterns, symbols and shapes that attract my eye.

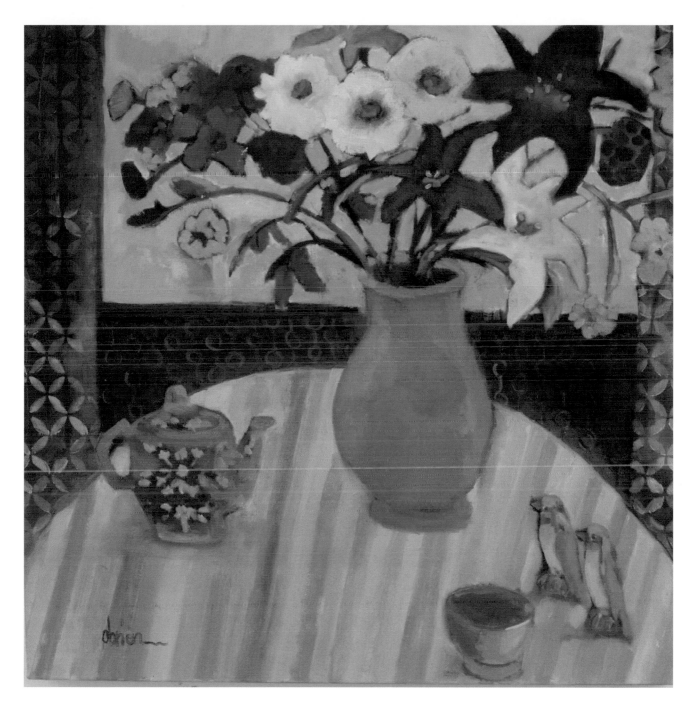

Time for Tea

This painting incorporates many items from my personal collection as well as symbols and shapes I love. The vintage vase, teapot and saltshakers are from my collection, and the patterns on the textiles and walls come from my library of sketches in my Painting Notes.

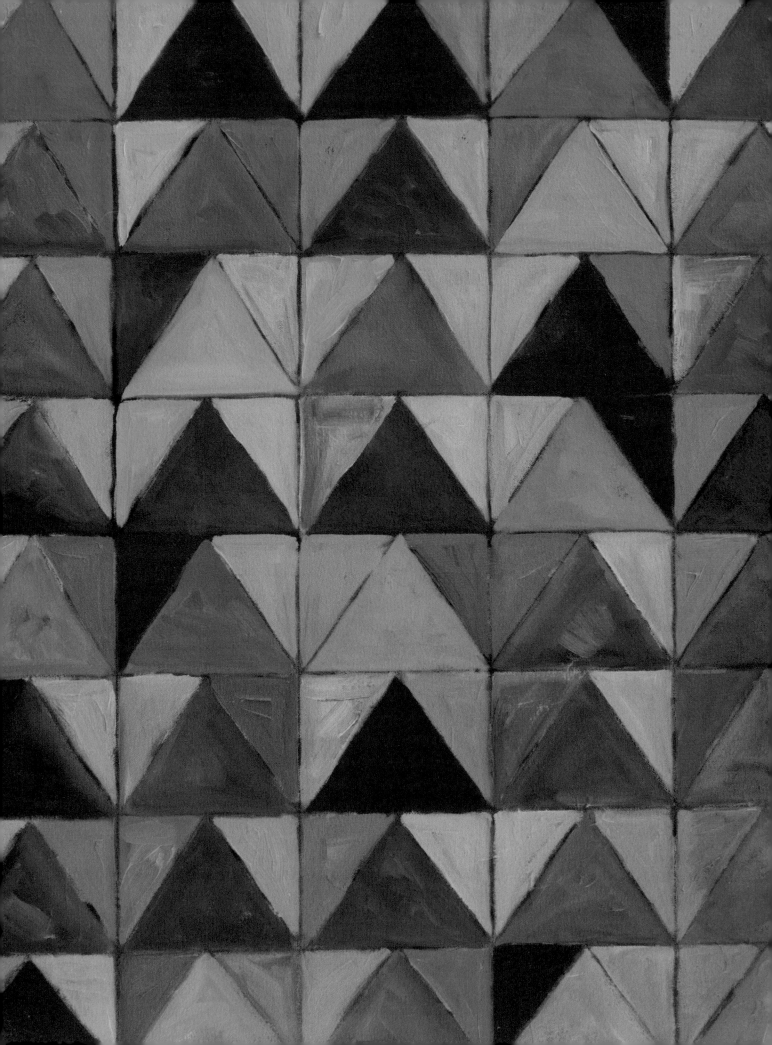

Expressive Composition, COLOR AND VALUE

Cubism was an attack on the perspective that had been known and used for five hundred years. It was the first big, big change. It confused people. They said, "Things don't look like that!"

—David Hockney

Knowledge and mastery of three elements of painting—value, composition and color—are extremely important to creating strong, expressive paintings. Although the Expressive style of painting is not about reproducing reality, it is still very important to harness value, composition and color to suit your purposes. Expressive painting does not limit your choices to what you can see, but expands your options to what you feel and want to say about the subject matter. That makes it even more important to understand these three elements of art.

Before you begin each painting, it's useful to ask the following:

- **Composition** - How can I create a dynamic design?
- **Color** - What color scheme could I use to convey my message in an expressive way?
- **Value** - How can I use dark/light contrast to increase the impact of this piece?

DYNAMIC Compositions

As you've studied painting, I'm sure you have run into many rules of composition. The first thing to remember is that in art there really are no rules—just guidelines that might help you meet your goals. Studying composition can seem like a daunting task, but it will truly speed up your learning process to understand some basic concepts, and then you can invent ways to break the rules. I'm going to share with you some ideas about composition that I have found useful, but you will find lots of other ideas out there. Just remember that much of what is written refers to a traditional or realistic style of painting and may not be useful if you want to paint expressively. As you plan compositions for expressive paintings, you will no doubt find your favorite compositions and create your own approaches.

Scale and Shape of Painting

The choice of canvas size and shape is the first step in composing a painting. Decisions should be made based on the type of painting and message you want to communicate. Very small paintings create intimacy by forcing the viewer to come closer, but they run the risk of being overlooked. Large paintings demand attention and can create moods varying from enveloping the viewer to aggression, depending on the subject matter.

The choice of shape for your paintings is almost unlimited—from squares, verticals and landscapes all the way to round paintings. Think about which size and shape will best suit your intentions.

Rule of Thirds

One easy way to find a natural location for the focal point of a painting is called the "Rule of Thirds." If you divide a canvas into thirds vertically and horizontally, the intersections of these lines will fall at what are natural focal points for a painting. These are the so-called "sweet spots" where the eye will naturally gravitate. If you place a center of interest in one of these spots, the composition will appear balanced and "right" to the human eye.

Variation of Elements

Paintings are more dynamic when there is variation in the elements in the painting. This includes object sizes and heights, spaces between objects and in the numbers of objects (uneven numbers always work better for some reason). Any kind of contrast attracts and holds the eye of the viewer.

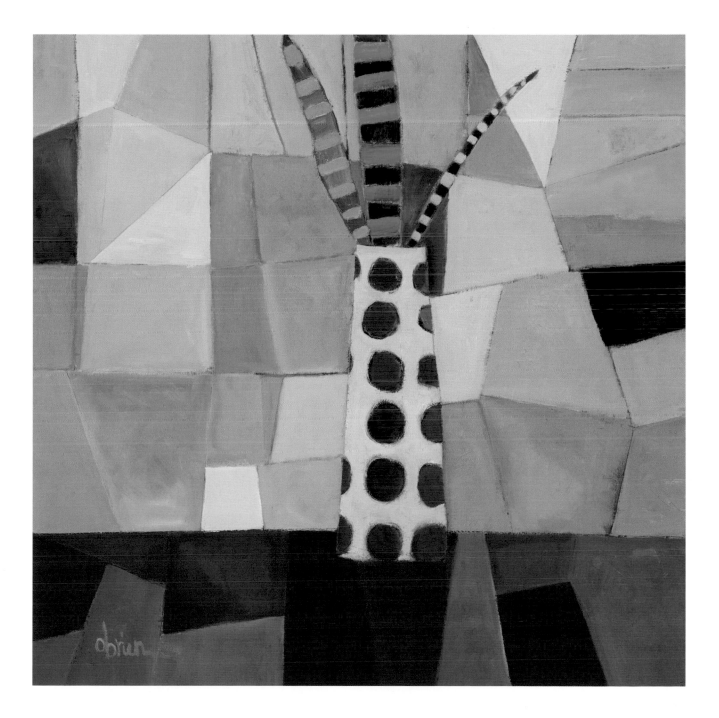

Perspective

The Expressionist painters transformed the idea of perspective or how objects are perceived on the picture plane beyond the previous scientific or traditional notions. Unusual perspective is one of the elements that also distinguishes expressive painting from the traditional. That doesn't mean that you can't use more traditional models of perspective in expressive painting, but it does mean that you are not limited to that style of perspective. It's useful to be aware of other approaches you can use to design your paintings. Three models of perspective include:

- **Linear Perspective**: Although it is likely the Greeks and Romans knew about linear perspective, that knowledge was rediscovered in the 1400s by Italian architect Brunelleschi when he described a mathematical system of "lines of sight" stretching to a single vanishing point in the distance. This idea quickly caught on with painters of the era as a device to convey distance.
- **Aerial Perspective:** Dutch painters were using aerial perspective in the fifteenth century, and it was utilized in the work of Leonardo da Vinci as well during this era.

Aerial perspective is based on the fact that atmosphere (dust and moisture) causes objects in the distance to be hazy or less distinct and slightly cooler. By cooling and lightening paint colors in the background, painters create a sense of distance in landscape painting, a technique used by most plein air landscape painters today.

- **Subjective or Conceptual Perspective:** In the early twentieth century, Cubism quite literally fractured traditional tenets of painting. Avant-garde artists broke through longstanding boundaries and redefined all aspects of painting, including perspective. Conceptual perspective is often described as personal, distorted, quirky or flat perspective. In reality, Chinese, Japanese and Islamic artists had used subjective perspective for thousands of years, but it was introduced in Western art by Cubist painters such as Georges Braque and Pablo Picasso. An example of a contemporary artist who utilizes conceptual perspective is British artist David Hockney. (He's on my personal artist ancestors list for this reason!)

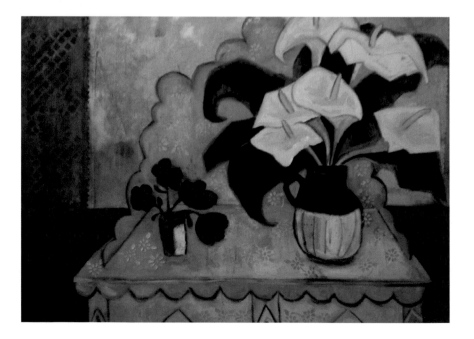

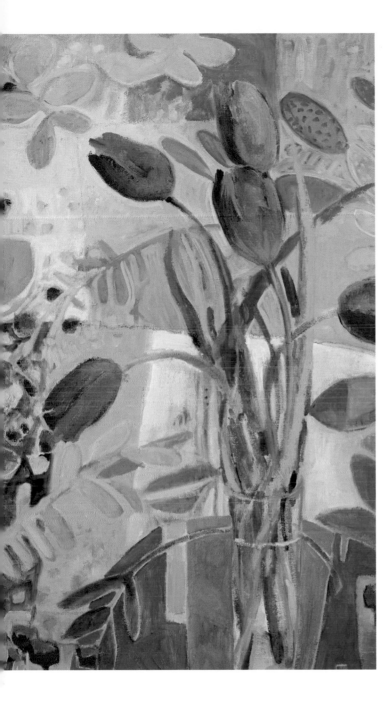

Composition Designs

These options refer to the way you actually lay out the design of your painting on the surface. There seem to be a lot of "don'ts" in most references on composition, but they mostly apply to realistic painting. I always get a kick out of the rule "Never place a focal point in the middle of a painting." Take a look at the work of Georgia O'Keeffe; she did this consistently and it worked quite well!

I believe anything is possible in expressive painting if you can make it work—that's the charm of this style of painting. Here are a few designs for compositions to think about:

- **S shapes:** Curving s-shaped lines lead the viewer into a painting. This design is often used by landscape painters but could be used in any composition.
- **Rectangular shapes:** Right-angled lines that divide the painting into unequal rectangular sections give the painting an element of stability or solidness.
- **Diagonal lines and triangular shapes:** These can be more exciting than rectangles or circles and add a sense of movement to a painting.
- **Clustering shapes:** Grouping shapes closely together creates a natural focal point.
- **Radically altered scale:** A dramatic exaggeration of the subject matter can create curiosity in the viewer.
- **Altered viewpoints:** Viewing objects from above or below the usual side view will draw the viewer's eye.
- **Unusual landscape compositions:** These are discussed in detail in chapter 5.

Expressive COLOR

Of all the elements of a painting, color is most associated with passion, and it is the engine that drives the Expressive style of painting. Color choices are very personal. You yourself most likely gravitate to certain colors in the act of painting just as you do in clothing and decor. As a confirmed colorist, one of my most difficult lessons in painting has been to harness my passion for color.

An understanding of color theory is essential but it doesn't have to be laborious or painful. Think of understanding color in painting as a series of adventures. There are a few basics that you may already know, but I will quickly cover them as a refresher.

Primary Colors

There are only three colors—**red, yellow** and **blue**— that cannot be mixed from other colors (amazing, right?) and they are called "primary" colors for that reason.

Secondary Colors

Each secondary color is a mix of two primary colors, so there are only three secondary colors: **orange, green** and **purple**.

Tertiary Colors

These are a mix of a secondary color with a primary color, and there are six possibilities: **red/orange, orange/yellow, yellow/green, green/blue, blue/purple** and **purple/red**.

To gain mastery over color in your paintings *plan* the color scheme before you begin. This is especially important for Expressive painters since you are not locked in to reproducing reality and have all of the choices on the color wheel (which can become overwhelming).

After you have painted many paintings with thoughtfully chosen color schemes, color choice will become second nature, but in the beginning you will save yourself a lot of do-overs if you plan your color scheme in advance.

It makes sense to start with a somewhat small palette of paint colors before you buy every color at the art supply store. Decide on a go-to palette and systematically use it for awhile to learn color mixing using fewer variables. Try out the techniques in this chapter to create color references to refer to as you plan your paintings. Look in magazines for color scheme ideas to add to your Painting Notes sketchbook.

Actual paint color can differ greatly by brand. Additionally, there are many variations of each *hue*. (A hue is what we typically refer to as a color.) Cadmium Red Light and Alizarin Crimson are both considered red, which makes them primary colors, but they are very different reds and will yield very different mixtures. To complicate matters more, there are dozens of secondary and tertiary paint colors with random names produced by myriad paint companies, each with their own twist on color. For these reasons, I recommend creating your own color wheel with the hues you are using on your palette. It isn't necessary to learn all of color theory to begin painting (although it's quite an interesting topic you might get hooked on!).

CHOOSING a Palette

Using straight tube color on a painting usually screams "beginner," so learning to mix interesting paint color is essential to your growth as a painter. I realize it's difficult for the colorists among us (myself included) to hold back from buying every color at the art store, but starting out with too many paint colors can actually delay your understanding of color.

You can always add more paint colors to your palette as you gain some experience. Starting to paint with a limited palette is a smart idea because it will help you learn the characteristics of different paint colors and the mixtures they can make.

To begin with, select tubes of a warm and a cool version of the three primary colors. Some painters choose to purchase tubes of secondary colors also, while others prefer to mix all of their secondary colors from primaries. You will have to let your tastes and budget be your guide. There are excellent experienced painters who keep their palettes small and mix everything they need from very few colors.

An easy way to determine if a color on the color wheel is warm or cool is to think of warm colors as reminders of the warmth of the sun and cool colors as the coolness of water such as mountain streams. This will help you remember that yellow, orange and red are *warm* colors and violet, blue and purple are *cool* colors. So if you create a painting using the cool colors of violet, blue and purple, it will have a feeling of coolness (the serenity of a mountain stream).

Where it gets tricky is when you realize that all colors can lean or bias toward warm or cool! What? You just told us which colors are cool and which are warm—now how do you tell what's warm and what's cool? Here's the deal: The colors of actual paint are not exactly like the pure colors you see on a color wheel—they come in endless variations. That is why it's possible to buy a "cool red" such as Alizarin Crimson or a "warm blue" such as Ultramarine Blue. Because paint colors are not pure light, they will all lean or bias toward either the warm end or the cool end of color temperature, and it's important to understand where each color lies on that spectrum. To really gain an understanding of how the hues of color line up regarding warm to cool, create a swatch using a dab of each of your tubes of red colors, lining them up from warm to cool. Your eye will begin to detect their warm/cool bias, and you will be able to choose the color temperature you want. Do the same for all of your blues, yellows, greens, oranges and purples. It's a great exercise and will help you a lot with color mixing!

Now, just to add to the wonderful complexity that is color, the temperature of a color in a painting is relative to what is around it. For example, a green mixture that looks warm on your mixing palette can look much cooler when used next to a bright warm yellow in a painting! Don't fret, though; you will start to gain an understanding of color temperature the more you paint. A very helpful reference for determining the temperature of different paint colors is the Gamblin website: gamblincolors.com/navigating. color.space/color.temperature.color.html.

I propose you adopt one of the suggested color palettes shown here and work with these paint colors until you feel you have mastered their mixtures. You will notice I have not included any earth colors (Burnt Umber, Ochre, Raw Sienna) or black, because you can mix rich versions of browns and blacks if you need them from the primaries and secondaries. If you have a love of certain colors, those might be the ones you buy first to expand your paint color collection.

Quick Tip

Sometimes the use of the term *palette* can be confusing. There is the "palette" or surface you place your paint on (glass, disposable palette sheets), and then there are the colors you select for a particular painting, which is also called your "palette" or "color palette."

Suggested Color Palettes

Basic Warm/Cool Primary Color Palette

My suggestion is to choose a warm and a cool of each of the primary paint colors for an initial color palette. Secondary and tertiary colors can be mixed from the variations possible with this palette. The following tube paint colors for a warm/cool palette are a great starting point.

 Cadmium Yellow Medium (warm)
 Lemon Yellow (cool)
 Cadmium Red Light (warm)
 Permanent Alizarin Crimson (cool)
 Ultramarine Blue (warm)
 Phthalo Blue (cool)
 Titanium White

Expanded Primary/Secondary Color Palette

This is a common palette of colors using purchased paint colors for the secondaries.

Primary Colors:

 Cadmium Yellow Medium (warm)
 Lemon Yellow (cool)
 Cadmium Red Medium (warm)
 Permanent Alizarin Crimson (cool)
 Ultramarine Blue (warm)
 Phthalo Blue (cool)

Secondary Colors:

 Cadmium Orange (warm)
 Indian Yellow (cool)
 Sap Green (warm)
 Phthalo Green (cool)
 Dioxazine Purple (warm)
 Quinacridone or Cobalt Violet (cool)
 Titanium White

A note about neutrals and black: Some neutrals that you might want to add to your palette include Yellow Ochre, Burnt Sienna, Raw Umber and Buff Titanium. If I need black for a painting I usually choose Ivory Black, or most often I mix a "black" using Alizarin Crimson and Ultramarine Blue.

Color Wheels/Charts

There are some wonderful commercial color wheels on the market, and I suggest everyone buy one at some point because of their ease of use. But I strongly advise you to create your own color wheel out of your particular palette of paint colors for two reasons. First, commercially printed color wheels give you a very general idea of what happens when you mix colors, but they don't come anywhere close to looking like the actual mixtures you will get from the paint colors you have on your palette. Second, there's no substitute for mixing your own colors—it is an invaluable lesson in color.

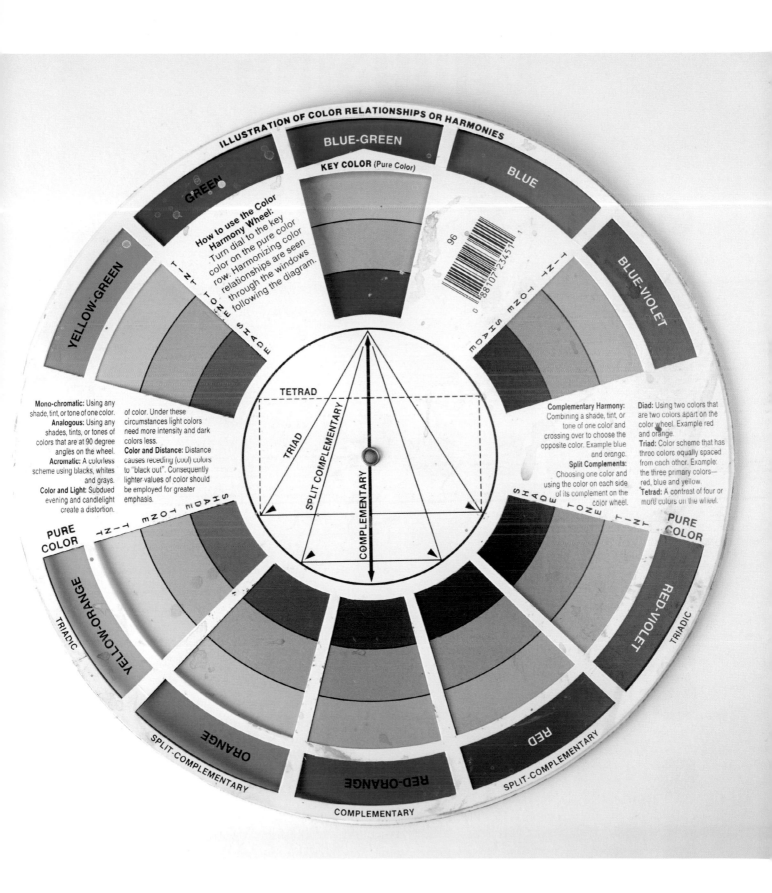

BLUE-GREEN

KEY COLOR (Pure Color)

GREEN

BLUE

YELLOW-GREEN

BLUE-VIOLET

How to use the Color Harmony Wheel: Turn dial to the key color on the pure color row. Harmonizing color relationships are seen through the windows following the diagram.

TINT TONE SHADE

SHADE TONE TINT

Mono-chromatic: Using any shade, tint, or tone of one color.
Analogous: Using any shades, tints, or tones of colors that are at 90 degree angles on the wheel.
Acromatic: A colorless scheme using blacks, whites and grays.
Color and Light: Subdued evening and candlelight create a distortion.

of color. Under these circumstances light colors need more intensity and dark colors less.
Color and Distance: Distance causes receding (cool) colors to "black out". Consequently lighter values of color should be employed for greater emphasis.

TETRAD

TRIAD

SPLIT COMPLEMENTARY

COMPLEMENTARY

Complementary Harmony: Combining a shade, tint, or tone of one color and crossing over to choose the opposite color. Example blue and orange.
Split Complements: Choosing one color and using the color on each side of its complement on the color wheel.

Diad: Using two colors that are two colors apart on the color wheel. Example red and orange.
Triad: Color scheme that has three colors equally spaced from each other. Example: the three primary colors—red, blue and yellow.
Tetrad: A contrast of four or more colors on the wheel.

PURE COLOR

TINT TONE SHADE

SHADE TONE TINT

PURE COLOR

YELLOW-ORANGE

RED-VIOLET

TRIADIC

TRIADIC

ORANGE

RED

SPLIT-COMPLEMENTARY

SPLIT-COMPLEMENTARY

RED-ORANGE

COMPLEMENTARY

CHOOSING
a Color Scheme

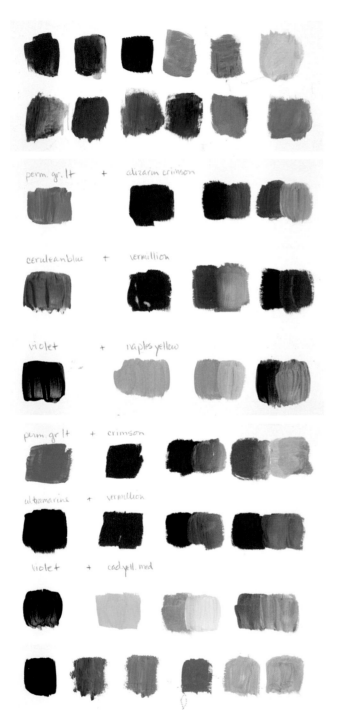

perm. gr. lt + alizarin crimson

cerulean blue + vermillion

violet + naples yellow

perm. gr. lt + crimson

ultramarine + vermillion

violet + cad. yell. med

Color scheme refers to a plan of color chosen for a particular painting. Over the years, painters have developed color schemes based on color theory. Choosing a color scheme for a painting in advance will help to harness the expressive painter's fervor to use every tube of color in one painting.

There are many variations on color schemes, and any good book on color theory will expand your knowledge of color to produce exciting results. I recommend gaining mastery of the following three simple color schemes as a systematic way to gain control of color in your work. The truth is that after completing many paintings, color schemes become intuitive or internalized for many painters. But early on, it helps to use the analytical brain to solve some of the many dilemmas of creating a powerful painting.

- **Analogous:** Analogous colors are those that sit next to each other on the color wheel. In an analogous color scheme, you choose three to four neighboring colors for your palette. You can use all of the variations of the colors within the section of the color wheel you have selected. This scheme is always harmonious.

- **Complementary:** Colors opposite each other on the color wheel are referred to as complementary. Complements create excitement because they have the most contrast. Look at advertising or sports teams and you will see mostly complementary color schemes in use. The Fauvist painters such as Matisse frequently used complementary color schemes.

Color Terminology Every Painter Should Know

Chroma:	Intensity of a particular color.
Color Palette:	Purchased paint colors selected by a painter.
Color Scheme:	Color strategy chosen for a painting. (Example: analogous or complementary.)
Hue:	The color family (red, blue, green, etc.)
Primary Colors:	Colors that cannot be mixed from other colors—red, yellow, blue.
Saturation:	Soft or faded vs. intense color.
Secondary Colors:	Colors—orange, green, purple—composed by mixing two primary colors.
Shade:	Variation on a color created by adding black.
Temperature:	Warm vs. cool color. Cool colors include blue, violet, blue-green; warm colors include red, yellow, orange. Color temperature can be relative according to surrounding colors; e.g., a blue can look warm next to a cooler purple.
Tertiary Colors:	Colors—red/orange, orange/yellow, yellow/green, green/blue, blue/purple, purple/red—made by mixing a primary color with a secondary color.
Tint:	Variation on a color created by adding white.
Tone:	Variation on a color created by adding gray.
Value:	Light vs. dark.

• **Analogous/Complementary:** Probably the most useful and most common, the analogous/complementary color scheme combines the beauty and harmony of the analogous colors on one side of the color wheel with a pop of complementary color from the other side. Use the analogous colors as the dominant color and the complementary color as the spark of color.

Up Next . . .

The following techniques on value, composition and color will provide a reference point for you to use in all of the projects in the book.

I recommend taking your time to complete these technique exercises before you begin painting. I think you will find them not only informative and useful but also fun!

Two-Value NOTAN DRAWING

In painting, as in life, you can get away with a great deal as long as you have your values right.

—Harley Brown

Limiting a painting to only black and white demonstrates the highest value contrast possible. Although you may not decide to paint with only black and white on your palette, it's useful to try this exercise while sketching to get a feel for how value difference can create drama in your work. This is especially useful if you find your work trending to all middle value, which can become boring. Even though expressive painting does not have to utilize the traditional technique called "chiaroscuro" (stark use of a pattern of lights and darks), it's important to see your compositions in terms of value contrast.

The following technique will demonstrate a two-value sketch using only black and white to demonstrate the power of stark value contrast. This exercise is referred to as "Notan" drawing. Notan is a Japanese approach to design, which translates shapes into light and dark flat forms.

What You Need

- ◻ black art marker
- ◻ pencil
- ◻ sketchbook

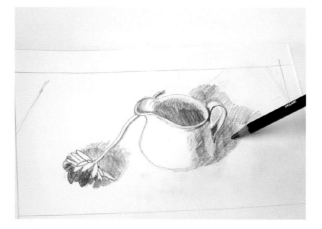

1 Find a simple subject, such as a small object on a table, with one light source. Do a quick, simple sketch of the scene.

2 Squint your eyes and using the black marker, create a pattern over the darkest darks of your pencil sketch. The light areas are created by the white of the paper.

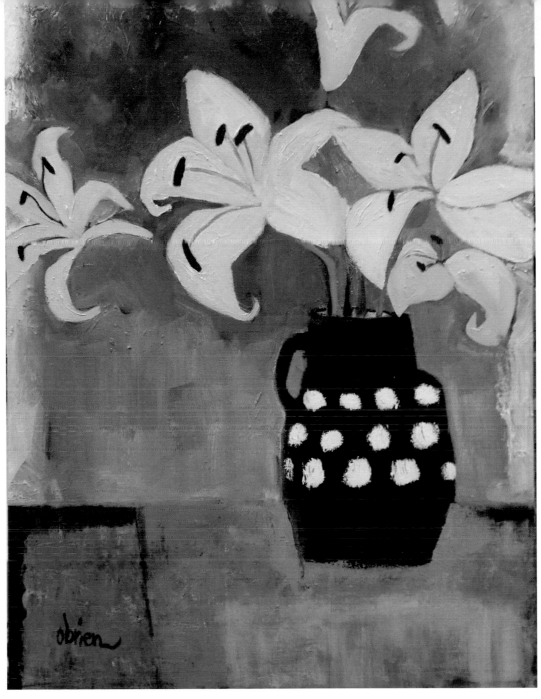

White Lilies in a Black Vase
This painting relies on strong black-and-white value contrast for high impact.

Quick Tip

Need more contrast? You can analyze the value contrast in your painting by taking a digital photo and shifting it to black-and-white mode to evaluate it. This can be quite informative and lead you to create more drama by going back in to pump up the value contrast.

Three-Value SCALE

Appreciation of value is merely training of the eye, which everyone ought to be able to acquire.

—John Singer Sargent

In this technique you will create a simple three-value scale—light, medium and dark values—to use as a reference scale to assess value in your paintings. Compare your future paint mixtures to this three-value scale as you are painting by taking a bit of paint on your palette knife and holding it next to the reference scale. If everything is leaning to the middle, you may want to add darks and lights to create greater contrast.

As you gain more experience in painting, you can expand your value scale to five values or even ten values if you feel you need more options, but a three-value scale is a great way to start.

QUICK WAYS TO ASSESS VALUE

Value can be quickly assessed by taking a digital photo of your sketch or painting and shifting it to black-and-white mode on your smartphone or digital camera.

There are also increasingly sophisticated apps for smartphones and tablets to assist artists with assessing value. These apps allow the artist to assess and adjust values on-screen to test out ideas for their work. Many of them have the capability of designing compositions as well. Two of the best in my opinion are:

• *Accuview: accurasee.com/iphone.html*
• *ValueViewer: markandlori.com/resources/apps/ValueViewer*

For a low-tech way to assess value, it's a well-known trick among artists that squinting at your sketch or painting will block out color and allow you to see values more clearly. Try it!

What You Need

- bristle flat brush, 1" (25mm)
- disposable palette sheet (gray if possible)
- paint, acrylic or oil: Ivory Black and Titanium White
- pencil
- ruler
- sturdy substrate, 4" × 6" (10cm × 15cm) (heavy watercolor paper, mat board, or bristol board)

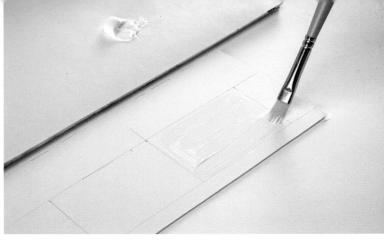

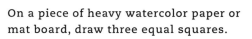 On a piece of heavy watercolor paper or mat board, draw three equal squares.

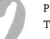 Paint the square on the right end with Titanium White.

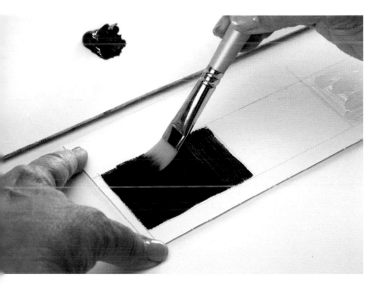

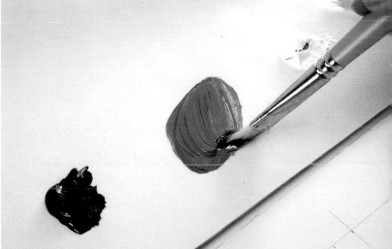

3 On the left end, paint the square pure black.

4 Mix white and black paint to create a middle gray value to fill the middle square. If you are using a gray disposable palette sheet, the middle gray value will match the palette.

5 Add the mixture to the middle square. Keep the value scale nearby (probably forever) while you paint.

 45

Composition OPTIONS

Composition is the art of arranging in a decorative manner the various elements at the painter's disposal for the expression of his feelings.

—Henri Matisse

Before you begin your painting, it's helpful to sketch out some options for your composition, taking into consideration the options mentioned in the introduction to this chapter. These include choice of canvas/paper size and shape, the rule of thirds for placement of objects, the importance of clear value differences and variation of the elements in the painting. Quick thumbnail sketches in your Painting Notes will help you learn the important role composition choices play in creating an expressive painting.

What You Need

- inspiration photos (your own or from a magazine)
- Painting Notes sketchbook
- pencil

1 In your Painting Notes sketchbook, create three simple sketches from photo references (or life) in pencil for the same subject matter.

2 You might vary the shape of each sketch (rectangular, vertical or square), try composing using the rule of thirds, shift the dark/light value contrast and/or vary the sizes and intervals between shapes in each sketch to brainstorm options for a dynamic composition.

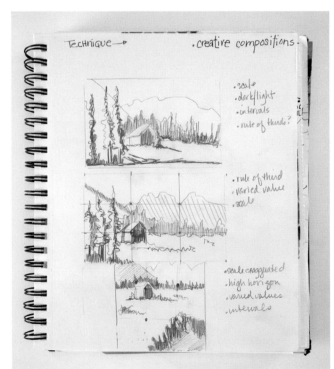

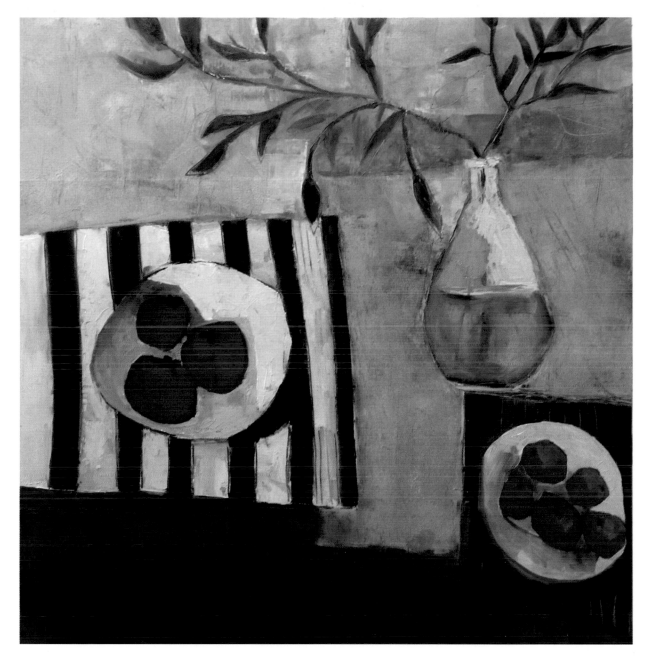

Fruit Table

This painting demonstrates an Expressionist approach to still-life painting—flattened space, unusual perspective and stylized shapes and colors.

Quick Tip

I'm not sure who first said "Color gets the credit while value does all the work," but it is a true statement. Strong value contrast goes a long way to increase the excitement quotient in paintings. Deliberate use of strong value contrasts (e.g., black next to white) will invariably pull the eye to that area of a painting.

Color Mixing Chart — WARM AND COOL

Colour is my day-long obsession, joy and torment.

—*Claude Monet*

We discussed the fact that all of the primary colors (red, yellow, blue) that you purchase will lean or bias toward the cool side or the warm side. In this exercise you will create a handy reference chart demonstrating the results when you mix these tube colors together to create your own secondary colors. Complete this exercise with the paints you have purchased and keep it handy as you begin to paint.

What You Need

- bristle flat brush, 1" (25mm)
- paint, acrylic or oil: one warm + one cool for each primary color—red, yellow, blue—six total—as well as white
- paper towels or rags
- pencil
- ruler
- sturdy substrate, 12" (30cm) square (heavy watercolor paper, mat board or bristol board)
- water container (acrylic) or Gamsol odorless solvent (oil)

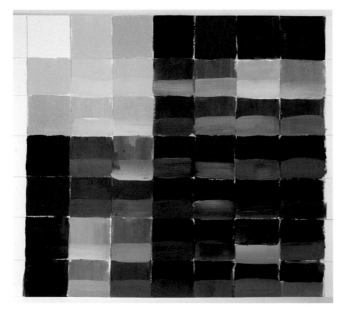

Finished chart

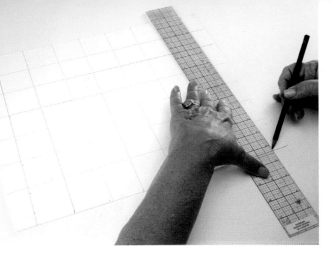

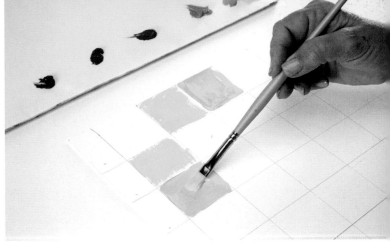

1 On the mat board or paper, draw a large square and divide it into an equally spaced grid of six squares in each direction.

2 Leave the square on the top upper left blank to allow the color mixtures to meet correctly across the chart. (You may wish to label the blocks along the top and left sides of the grid with the names of the tube paint colors.) Begin painting the squares, mimicking the order of colors in each direction. Here I'm beginning each row with the cool yellow and then the warm yellow. This first row and column will be filled with paint straight from the tubes. Clean your brush each time you change colors.

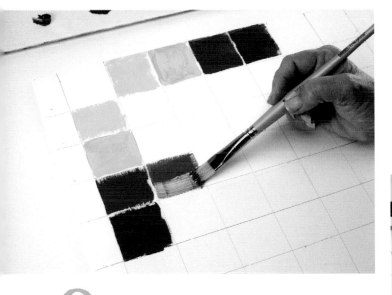

3 Begin creating mixtures of two colors as they intersect in each of the blank squares. In this photo I have mixed the cool yellow with the warm red to create a variation on orange.

Add a bit of white to the mixture, then paint a swipe of it in the bottom half of the square. This shows you what the tint looks like.

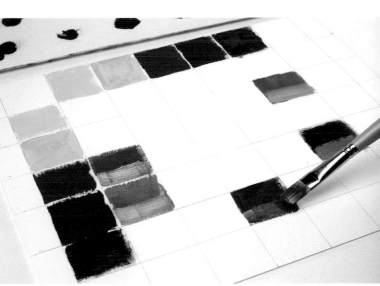

4 Continue adding and mixing colors throughout the grid, continuing to add a tint to the bottom of each mixture.

COLOR WHEEL
with Purchased Paint

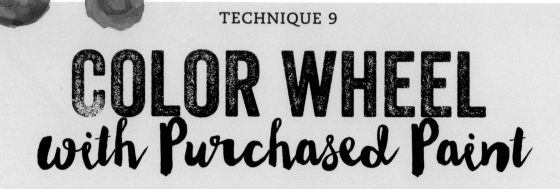

Color is a power which directly influences the soul.

—Wassily Kandinsky

Actual paint colors differ significantly from those you find on a purchased color wheel. This is why it's useful to create your own color wheel from the paint colors you have purchased to serve as a visual reference in your painting. This exercise demonstrates the creation of a personal color wheel composed of primary colors—red, blue and yellow—and the secondary colors created through mixing.

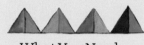

What You Need

- ▢ bristle flat brush, 1" (25mm)
- ▢ compass or round surface to trace (such as a plate)
- ▢ paint, acrylic or oil: one warm + one cool for each primary color—red, yellow, blue—six total—plus white
- ▢ paper towels or rags
- ▢ pencil
- ▢ ruler
- ▢ sturdy substrate, 12" (30cm) square (heavy watercolor paper, mat board or bristol board)
- ▢ water container (acrylic) or Gamsol odorless solvent (oil)

1 On your surface, draw a circle using a compass or a plate as your template. Draw another circle in the center of the larger circle, about half the size. Divide the circles into six equal pie-shaped wedges by drawing a line dividing the circle in half, then dividing each half into thirds.

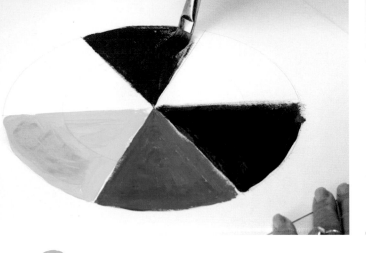
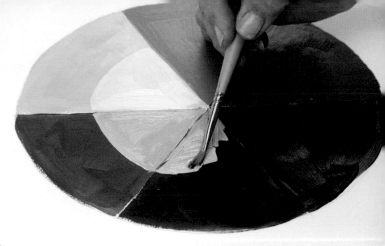

2 Paint red, blue and yellow primary colors in the outer sections of three wedges around the circle with a blank wedge between each primary color. Begin mixing the primary colors to create secondary colors and paint those between the primary wedges.

3 Continue for the remaining secondary colors. Next, mix some white with each of the six colors and fill each of the inner portions of the wedges to create tints of each of the colors.

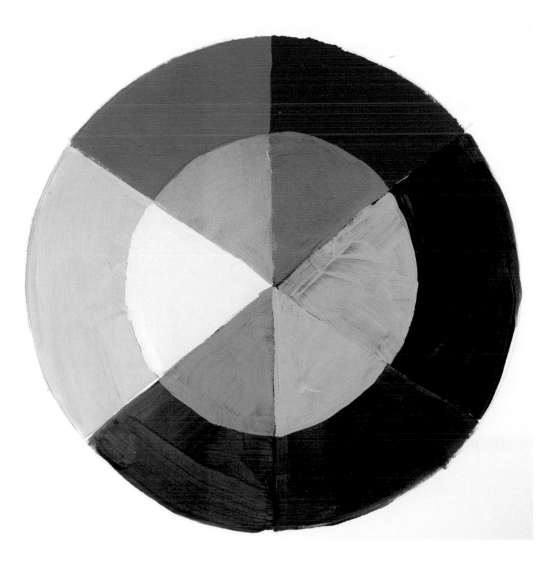

"GO-TO" Color Schemes

I prefer living in color.

—David Hockney

It's helpful to have color charts for analogous, complementary and analogous/complementary color schemes done with your favorite hues. There are many variations on the same hues of colors available in both acrylic and oil (e.g., Cobalt Blue, Cerulean Blue, Phthalo Blue), and your choice of color will greatly affect the mixtures you create. I recommend choosing your color scheme and paint colors and creating a color chart as a reference for each painting. See the Choosing a Color Scheme section in this chapter for a more in-depth discussion.

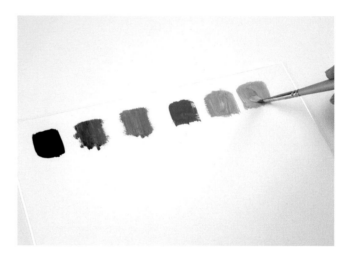

What You Need

- ☐ bristle flat brush, 1" (25mm)
- ☐ paint, acrylic or oil: your chosen palette
- ☐ paper towels or rags
- ☐ sturdy substrate scraps (heavy watercolor paper, mat board or bristol board)
- ☐ water container (acrylic) or Gamsol odorless solvent (oil)

1 Create color swatches on a scrap piece of watercolor paper or mat board with colors from your palette for each of the following color schemes:
- analogous
- complementary
- analogous/complementary
 - This is an analogous color scheme going from violet through green.
 - Refer to the section on color schemes in this chapter for more discussion.

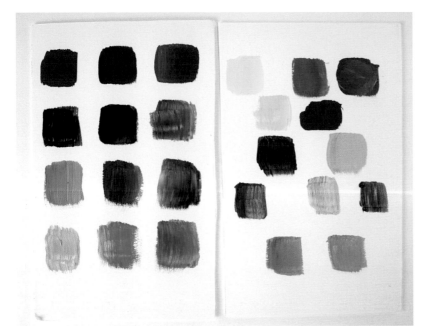

2 This is an analogous/ complementary scheme— lots of analogous blues and greens with smaller touches of the complements of red and orange.

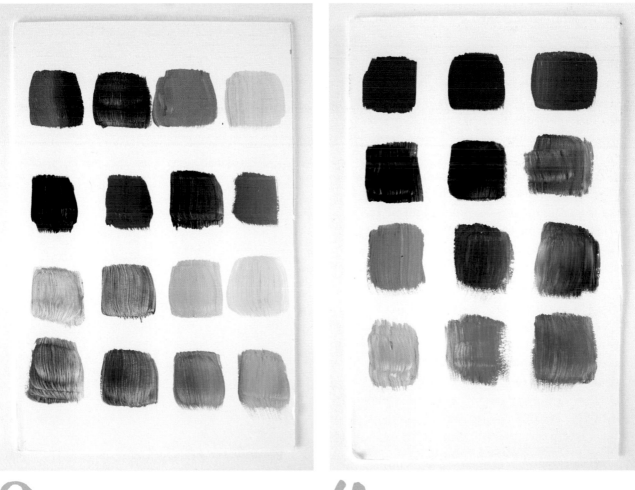

3 This analogous color scheme also shows the addition of white to the selected colors to create tints.

4 This is a complementary color scheme using equal amounts of blue and orange.

Balancing Color WITH NEUTRALS

What is my experience if it is not the color?

—Georgia O'Keeffe

Bold color can appear more striking when balanced with beautiful neutrals—that's what every painting teacher has told me. It took me longer than most to hear that message, but it turns out it's true.

While there are many beautiful neutral earth colors (Burnt Umber, Burnt Sienna, Yellow Ochre, Raw Sienna, Raw Umber) ready-made in tubes to use as your neutrals, I recommend you try mixing some neutral colors from your primary and secondary colors. Experiment with graying down, which is a method of neutralizing color by adding a touch of its complementary color (the one directly across the color wheel) to take the edge off a color that might be too bold. This is a great way to add interest and complexity to your painting. Start with a small touch of the complementary color and add more as needed. Then try a little white to lighten the neutral hue.

All neutrals possess a color bias—they lean toward cool or warm. You will quickly begin to create neutral mixtures intuitively; just ask yourself if the neutral you are looking for is warm or cool, dark or light and adjust accordingly. Try out some creative neutral color mixtures next to some bold colors. To get started with mixing neutrals, try mixing complementary colors from across the color wheel and then adding a touch of Titanium White. Be sure to label your mixtures for future reference.

What You Need

- bristle flat brush, 1" (25mm)
- paint, acrylic or oil: your chosen palette
- paper towels or rags
- sturdy substrate scraps (heavy watercolor paper, mat board or bristol board)
- water container (acrylic) or Gamsol odorless solvent (oil)

Quick Tip

Got mud? The infamous "mud" mixtures that we all fear creating are actually beautiful neutrals. They become even more beautiful with the addition of a bit of white paint.

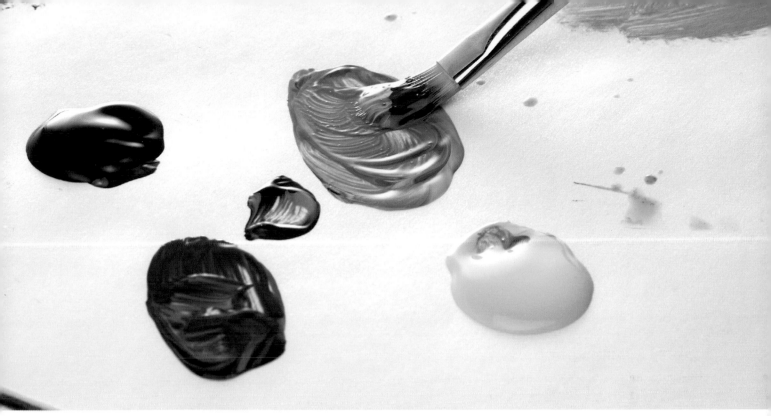

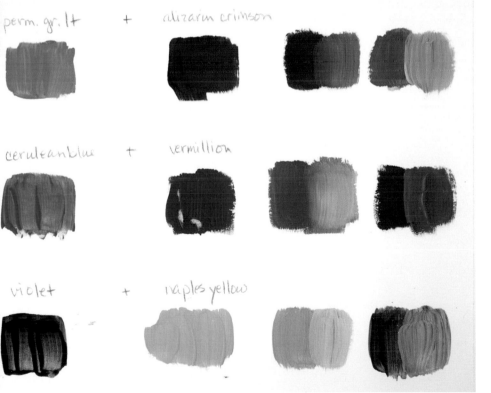

perm. gr. lt + alizarin crimson

cerulean blue + vermillion

violet + naples yellow

1 On watercolor paper or mat board, create swatches of neutral mixtures by starting with a primary or secondary color and adding small amounts of its complementary color across the color wheel. After you mix each neutral, take a small dab of it and add white to create the tint.

2 Here are some mixtures of complementary colors in varying amounts to create beautiful neutral colors. Record the names of the paint colors used on the mat board and in your Painting Notes sketchbook and save as references for your paintings.

MIXING
Creative Greens

Nature is my springboard. From her I get my initial impetus.

—Milton Avery

Some painters believe that greens are the most challenging colors to work with in a painting. There are many variations on green in the art store, but I think it's exciting to see how many greens can be mixed from other colors instead. Try mixing some creative, dazzling, mysterious greens. Let me just throw this in—green happens to be my favorite color!

GREEN POSSIBILITIES

Create a creative greens chart by trying out any of the following combinations in addition to any others you can think of.

Cerulean Blue + Cadmium Lemon

Ultramarine Blue + Cadmium Yellow Light

Phthalo Blue + Cadmium Lemon

Ultramarine Blue + Yellow Ochre

Ivory Black + Cadmium Lemon

Ivory Black + Cadmium Yellow Light

Cobalt Blue + Alizarin Crimson + Cadmium Lemon + Titanium White

Ultramarine Blue + Cadmium Red + Cadmium Yellow Light

Cerulean Blue + Alizarin Crimson + Cadmium Lemon + Yellow Ochre

Phthalo Blue + Alizarin Crimson + Cadmium Lemon + Titanium White

Ultramarine Blue + Alizarin Crimson + Cadmium Yellow Light

Sap Green + Cadmium Yellow

Viridian + Cadmium Lemon

What You Need

- bristle flat brush, 1" (25mm)
- paint, acrylic or oil: all of the yellows, blues, greens and reds that you have on hand
- paper towels or rags
- pencil
- sturdy substrate scraps (heavy watercolor paper, mat board or bristol board)
- water container (acrylic) or Gamsol odorless solvent (oil)

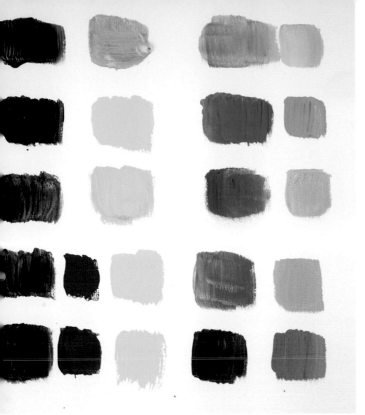

1 Create a grid of paint swatches using various combinations of blue and yellow. Add a bit of the complementary color red to some of the greens to create more neutral greens.

2 Label the mixtures for future reference and keep the creative greens chart handy to use as a reference when painting.

sap green + cad. yellow med

viridian + cad. lemon

sap green + cad. yellow lt

cerulean + cad lemon

turq + cad. lemon

ultra + cad. yell lt

ultra + yellow ochre

ivory + cad lemon

ivory + cad yell med

ultra + cad. yell med

turq + cad yell med

TRY CREATIVE OPTIONS WITH OTHER COLORS

Look at all of your color choices now! It only gets better as you begin to create your own mixtures. At some point you may want to take these techniques further by creating mixing charts for all of your various purchased tubes of color. I use a lot of reds, pinks and magentas in my work, so I created a color sampler with these colors to help me choose which one I want to use while I am painting.

57

"Go-To" Color Scheme
GRID PAINTING

I found I could say things with colors and shapes that I couldn't say in any other way—
things I had no words for.

—Georgia O'Keeffe

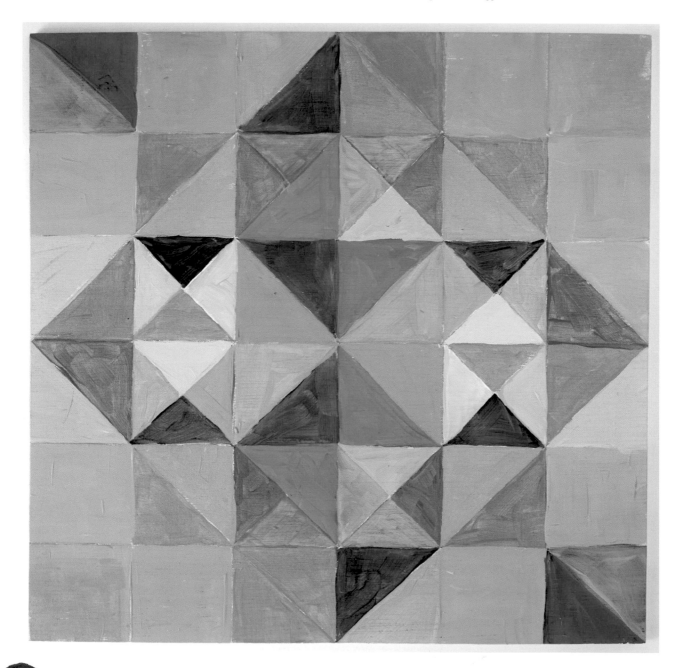

For this project, select a color scheme of three to five colors. Then create a simple geometric grid painting using only mixtures from your color scheme plus a little Titanium White and Ivory Black. Try to create as many color variations as you can, using only the colors in your color scheme. This exercise will demonstrate the myriad variations in color you can achieve with just a few colors.

What You Need

- ¤ bright brushes, ½", 1", 2" (13mm, 25mm, 51mm)
- ¤ disposable palette sheet
- ¤ gloves (optional)
- ¤ paint, acrylic or oil: colors in your "Go-To" Color Scheme from Technique 10 plus Titanium White and Ivory Black
- ¤ paper towels or rags
- ¤ pencil
- ¤ ruler
- ¤ substrate, 18" × 18" (46cm × 46cm) (heavy watercolor paper, canvas or panel)
- ¤ water container (acrylic) or Gamsol odorless solvent (oil)

1 Create a geometric grid of any shape or design on your paper or canvas by lightly drawing in lines using pencil and a ruler (or freehand if you feel adventurous).

2 Choose a color scheme (analogous, complementary, analogous/complementary) from the samples in your Painting Notes. Lay out these paint colors plus Titanium White on your palette.

- Using only these color mixtures (no straight tube colors please!), fill in the paper/canvas/panel completely. Add variation by adding white to color mixtures, using thicker paint and/or varied brushstrokes.
- Stand back and check your composition, value map and color choices, and add finishing touches where needed.

STILL LIFE WITH
Creative Green Mixtures

*I put in my pictures everything I like. So much the worse for the things—
they have to get along with one another.*

—Pablo Picasso

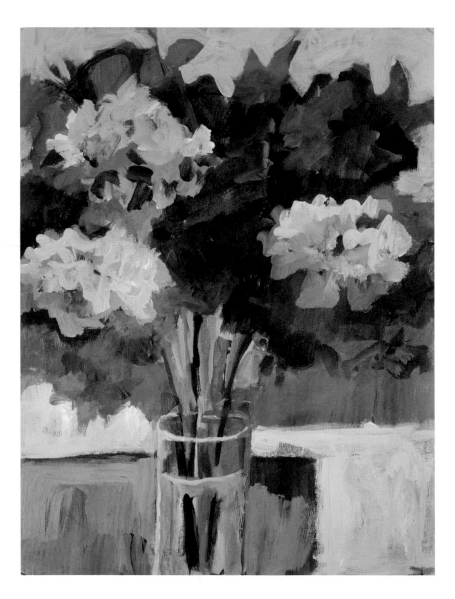

It's too easy to fall into a pattern of creating the same few mixtures of color. Floral still-life paintings are a wonderful opportunity to push color, especially creative variations on green. Use the creative greens color chart you created in Technique 12 to add variation to the foliage.

Quick Tip

When you don't have flowers available to paint, it is possible to use photos as reference material. When you do have flowers, think about taking a quick snapshot with your phone to save for times when flowers aren't available. Decorating magazines are a great source for flower photos. Clip a few of these and paste them into your Painting Notes to stir your imagination for floral still-life paintings.

What You Need

- □ bright brushes: ½", 1", 2" (13mm, 25mm, 51mm)
- □ paint, acrylic or oil: analogous/complementary color scheme
- □ Painting Notes sketchbook (with charts of creative green mixtures)
- □ paper towels or rags
- □ pencil
- □ photo reference of vase of flowers
- □ substrate, 11" × 14" (28cm × 36cm) (heavy watercolor paper, canvas or panel)
- □ water container (acrylic) or Gamsol odorless solvent (oil)

1 Using your photo reference for inspiration, quickly sketch thumbnails of three possible still-life compositions in your Painting Notes sketchbook.

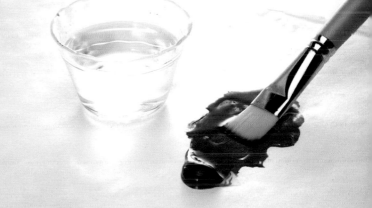

2 Lay out quarter-size pools of paint on your palette and assemble your other materials. Acrylic paints should be thinned with water; oil paints with odorless mineral spirits.

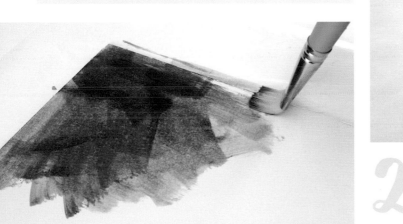

3 Apply a thin transparent underpainting in a warm color to the white canvas, panel or paper.

4 Using the same underpainting color, loosely draw a map of the composition on your canvas—3 to 5 large shapes are enough. Remember to vary sizes of the flowers, use an uneven number and make one flower the star of the show!

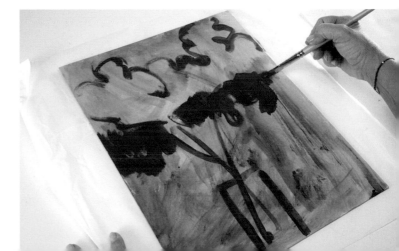

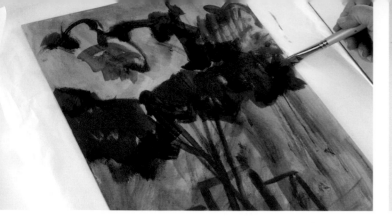

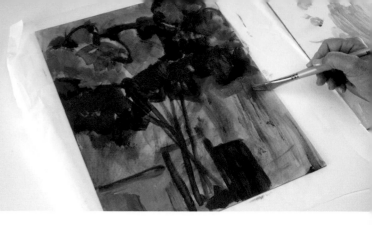

5 Block in these large shapes in a darker color with quick, sketchy strokes—no details at this point. Cover the entire canvas with loose, sketchy blocks of color to fill in the map of shapes. Continue to keep your paint thin until the final layer.

6 Stand back and check your composition, value map and color choices. Remember to squint to see values. Make adjustments if needed. Continue to add dimension by using thicker paint, creating variations in value, color and brushstrokes.

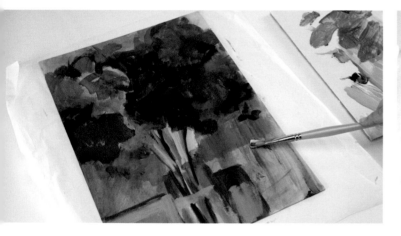

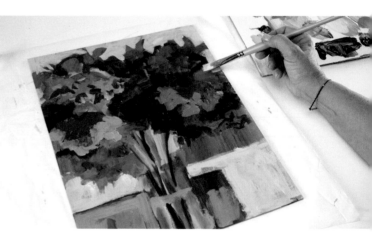

7 Add the next layer of paint in the background and the flowers and vase, remembering your color scheme. In this painting the analogous reds, pinks and purples dominate with accents from various complementary greens. Add a layer of loose detail to the flowers by mixing variations of color in lighter values. I usually think of adding three values of color to flowers. Avoid falling into the trap of too much detail in your florals; keep your strokes loosely painted with a medium to large brush.

8 Allow your work to rest overnight and take another look to assess what your painting might need to finish it. This is the point when you can add detail such as pattern in your tablecloth, vase or background, small touches of contrast in your flowers, or alter the value contrast between the subject and the background as I have done by adding a light value of off-white to the background to make the flowers pop.

Sign up for our free newsletter at www.CreateMixedMedia.com

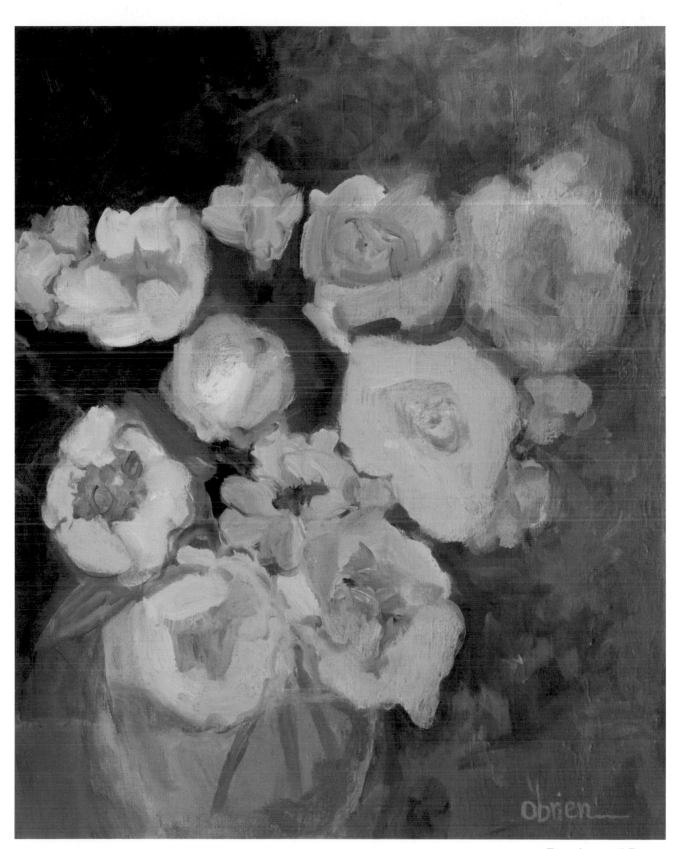

Peonies and Roses

This is an oil painting that utilizes an analogous color scheme of blues, violets and purples with the addition of complex mixtures of neutralized greens.

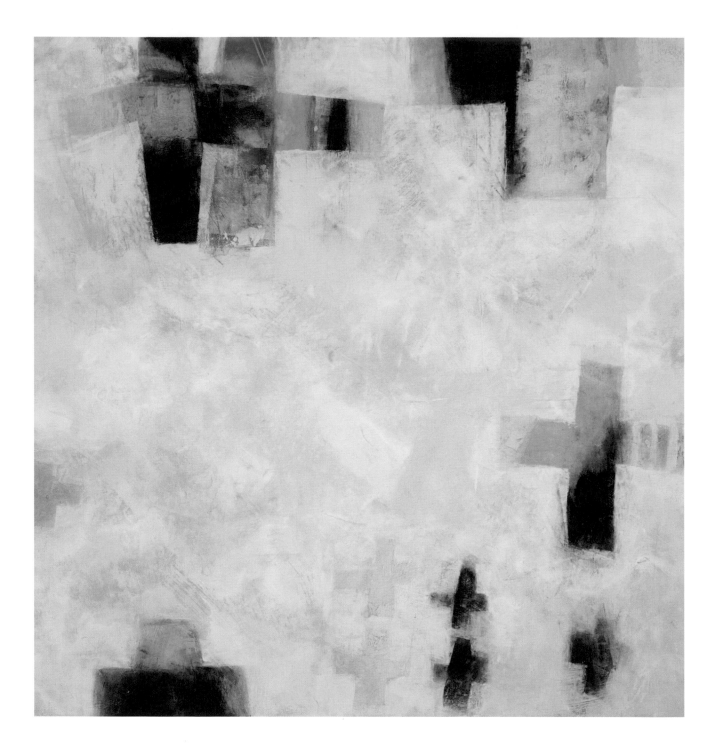

Sign up for our free newsletter at www.CreateMixedMedia.com

CHAPTER 3

Mixed-Media
PAINTING

Collage is the twentieth century's greatest innovation.

—Robert Motherwell

Mixed media simply means the use of more than one medium (paint, paper, clay, etc.) in the same work of visual art. Although combining mediums in works of art has been done in cultures for many centuries, in 1912 Pablo Picasso and Georges Braque revived mixed media in contemporary art by producing collage and assemblage pieces. Subsequently, mixed media has thrived and now includes just about anything artists can dream up including digital forms of mixed media.

Mixed-media techniques are always expanding as new art materials and artists' imaginations continue to evolve. There are also a great number of books with variations on mixed-media techniques. I suggest you try some of the many techniques for yourself and create a library of mixed-media techniques that work for you and that you can pull from to use in your work. The trick is to use mixed media judiciously to enhance the intention of your painting and not allow the materials to take over. I believe it's important to try a series of mixed-media paintings using only one or two techniques. In other words, don't try all of them in one piece. In this chapter I will share some mixed-media techniques I've found successful in my painting. I'm sure you will find many more as you look around.

GATHERING
Mark-Making Tools

Great art picks up where nature ends.

—Marc Chagall

Mixed media opens the creativity door to a world of tools for making marks. Once you begin looking, you will discover the joy of the hunt for unconventional tools. Grab a canvas tote bag and start the scavenger hunt at home. The first place to start is in your kitchen, searching through the drawers of utensils that are seldom used. Anything from dish scrubbers to mesh produce bags is fair game. The next obvious goldmine for repurposed tools is the garage or toolshed. After you have exhausted your resources on the home front, branch out to thrift stores, yard sales, discount stores and hardware stores.

Gather as many tools as you can find and then try them out on a scrap of paper or cardboard. You may wish to keep your practice sheets for reference.

IDEAS FOR TOOLS

- *Thrift Shops/Yard Sales: oddly shaped items you can use as stencils or stamps, rough fabrics such as burlap*
- *Kitchen: graters, mesh bags, rubber shelf liner, cookie cutters*
- *Hardware Store: screen mesh, trowels, paint scrapers, faux painting tools, stencils*
- *Outdoors: sticks, leaves, rocks*
- *Household: old credit/room key cards, combs, found papers, junk mail, packing boxes, Bubble Wrap, wallpaper scraps, foam pieces, sponges*
- *Art or Craft Store: palette knives, sculpture or ceramics tools, printmaking tools, rubber stamps, foam stencils*
- *Recyling (or Trash) Items: Styrofoam food trays, plastic (acrylic paint does not stick to plastic labeled HDPE), plastic wrap, cardboard, packing inserts, tops from bottles, cereal and other thin cardboard boxes*

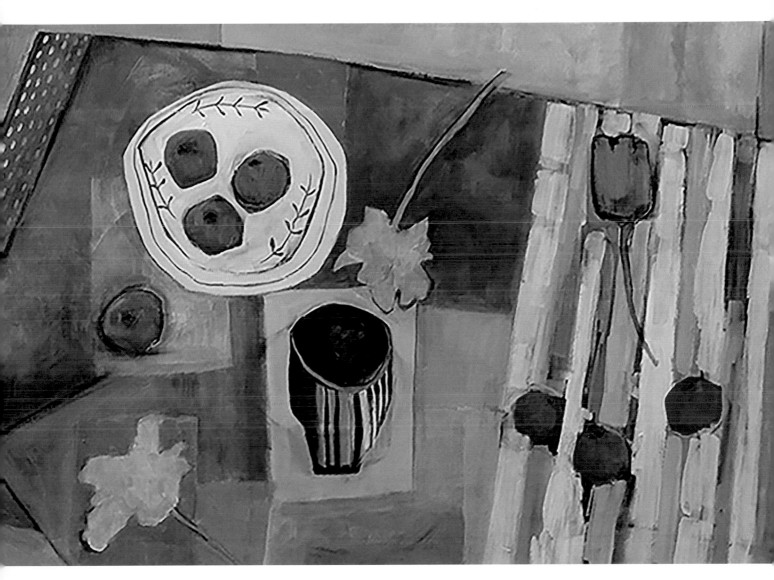

Spring Table

This mixed-media acrylic painting is an example of a modern "deconstructed" composition for a still-life painting that incorporates collage, pencil, crayon and pastels.

TECHNIQUE 14

STAMPS, Stencils and Masks

Do anything you like, but do it with conviction!

—Henry Miller

What You Need

- acrylic paint
- bristle brush, 1" (25mm), inexpensive or worn out
- contact paper
- craft foam with sticky back
- heavy craft scissors
- matboard scraps
- Painting Notes sketchbook
- pen or marker
- support: firm panel or heavy watercolor paper cut into smaller sizes
- thin cardboard (cereal boxes, other product packaging, etc.)
- water container

There are lots of manufactured stamps, stencils and masks out there to embellish your work, but wouldn't it be more fun to make your own one-of-a-kind pieces? Before you invest in manufactured products, try creating stamps, stencils and masks in your own expressive style. It's cheap and lots of fun.

Stamps

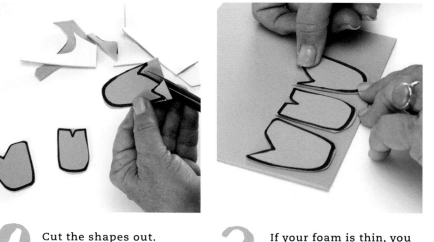

1 Draw your shapes on a sticky-backed foam sheet.

2 Cut the shapes out.

3 If your foam is thin, you might want to adhere the cutout to a second piece of foam.

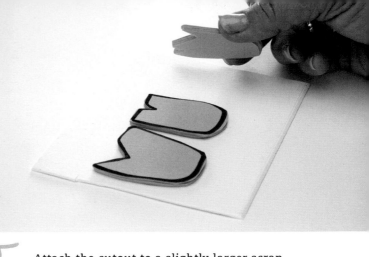

4 Cut out the shapes again.

5 Attach the cutout to a slightly larger scrap piece of matboard.

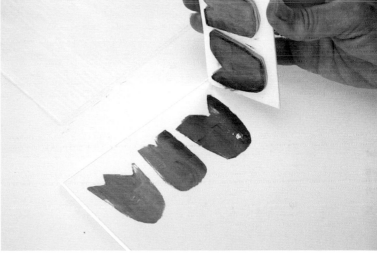

6 Brush acrylic paint on the surface of the stamp.

7 Use as a stamp on paper or panel.

Random stamps created from craft foam—one of a kind!

Quick Tip

Found items can be used as stamps, stencils or masks as well: torn or cut paper shapes, leaves, feathers, lace, corrugated cardboard, embossed paper, caps from bottles, odd-shaped objects.

Stencils

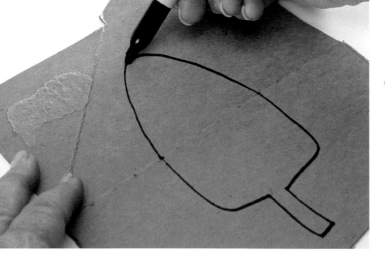

1 Recycle thin cardboard food boxes (cereal, cake mix type) by cutting along one side and bottom to create a large cardboard surface. Using ideas for shapes from your Painting Notes, draw shapes for stencils onto the cardboard.

2 Draw shapes on the cardboard and cut them out by either making a hole and cutting into the shape or folding the cardboard like cutting valentines. Try cutting random shapes—circles, stripes, squares, squiggles, anything you can dream up. The idea is to not to look store-bought perfect!

3 Cut each shape out with scissors.

4 You now have a stencil. If you are able to preserve the inside portions as you cut out the stencils, save the cutout pieces to use as masks.

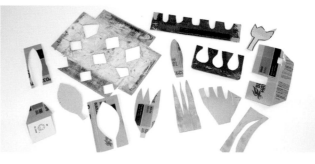

Random one-of-a-kind stencils and masks. You can't buy these, you have to make them!

Sign up for our free newsletter at www.CreateMixedMedia.com

Masks

3 Smooth out the contact paper "sandwich" to get rid of bubbles. Cut out the image shape with sharp scissors, and you have a stencil and a mask of your shape.

1 You can also use images or shapes found in magazines as masks. To give the magazine paper some additional substance, sandwich it between two pieces of contact paper. Begin by sticking the back of the image to one sticky side.

4 Place the mask on your test sheet and paint over it with acrylic paint.

2 Then adhere the front of the image to a second piece of contact paper.

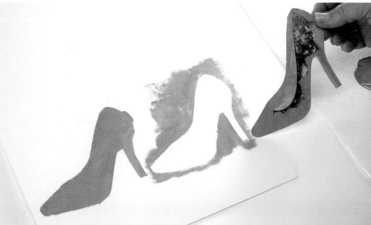

5 Carefully lift up the mask to reveal your image. Try out the stencil version of your image as well on your test sheet.

For additional downloads from the book, go to: www.CreateMixedMedia.com/BoldExpressivePainting

Gelli Plate
PRINTING

Great things are done by a series of small things brought together.

—Vincent van Gogh

Beware! Gelli Plate monoprinting is highly addictive! It is so much fun and yields surprising results, which appeals to those of us who lean toward the intuitive approach to painting. The Gelli Plate is a nontoxic gel substance infused with mineral oil that will accept most water mediums for monoprinting. It is also extremely sensitive to creating marks from items added to the surface such as stencils, textures and masks. The Gelli Arts website (gelliarts.com) has all of the information you need to print successfully with a Gelli Plate, including videos you should watch for more tips and ideas. The good news is that all of your print experiments can be saved as great collage material.

What You Need

- blunt object such as a paintbrush handle
- brayer, 4" (10cm) soft rubber (Speedball)
- Gelli Art Gel Printing Plate, size of your choice
- nonporous smooth surface (glass panel, Mylar or disposable palette sheet)
- paint: acrylic fluids or craft acrylics
- surface: your choice (Painting panels, canvas, watercolor paper or dry wax sandwich sheets all work well, but do not use glossy photo paper; it can damage the Gelli Plate.)
- water

1 Place the Gelli Plate on a smooth nonporous surface. Squeeze a blob of acrylic paint on the Gelli Plate and roll it out with a brayer to cover the surface thinly.

2 Apply a second color and mix it in a bit. The fun part of monoprinting is you never know what you will get, so just experiment with this. Add some texture by lightly scraping through the paint with the end of a blunt object such as a paintbrush handle.

3 Lay the paper or print surface on top of the plate and smooth it with your hands.

4 Lift the surface up to reveal your print.

5 You can frequently pull a second print from the plate; try sprinkling a little water on the leftover plate to keep it loose and moist.

6 Results of this type of printing are always a surprise!

7 Add a second color of paint and/or make some marks in the paint, and print on the same paper again for added effect.

8 Try positioning your paper in a different way.

9 Surprises are part of the joy of this process.

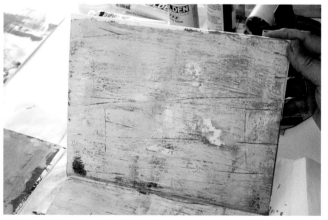

10 Keep going by adding variations and printing again. There are endless possibilities with this method of monoprinting!

Sign up for our free newsletter at www.CreateMixedMedia.com

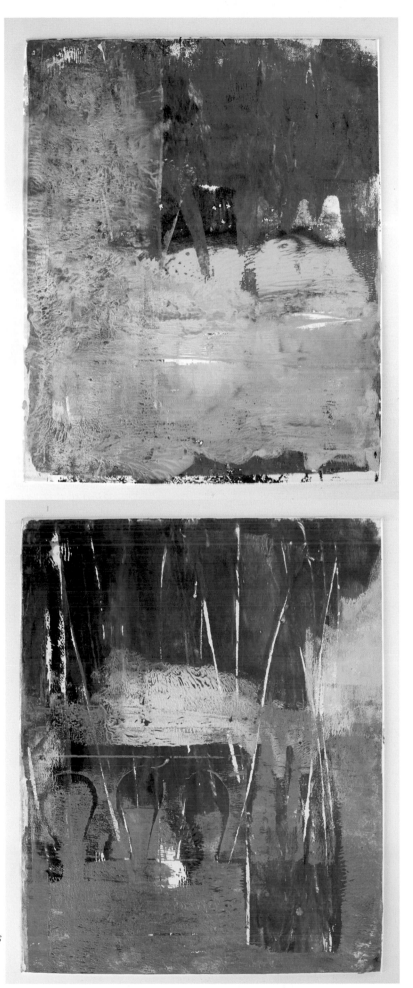

Gelli Plate monoprints

75

Creating and Collecting COLLAGE MATERIALS

Always be on the lookout for the presence of wonder.

—E.B. White

Since Pablo Picasso first incorporated newspapers and ephemera into his paintings in the early twentieth century, inventive artists have extended the definition of collage materials to include almost anything. You may have vintage paper or ephemera in your files that will make great collage material. I have always been attracted to old things and have accumulated lots of old books, magazines and tiny objects such as buttons and findings. Almost anything goes—collage materials are everywhere.

Collecting paper for collage can become an obsession, so think about storage as you begin to collect. Plastic translucent boxes work well to store materials by color. If you really take on collage as part of your artistic process, you will appreciate developing an organizational plan for what will soon become an overwhelming amount of material.

It helps to collect and/or make materials to use for collage in advance to create a stash of materials ready when the creative muse hits you. I usually set aside a half day to replenish my stash of painted collage papers. Get out your materials and clear your tabletops for drying. This is a somewhat messy process but it goes very quickly, so you might as well create a lot of it. Here are three methods of creating collage paper that I use.

What You Need

- baby wipes or hand sanitizer
- brayer (option 3)
- Bulldog clip
- deli paper (option 3)
- fluid acrylic paint and/or acrylic ink
- Gelli Printing Plate (option 3)
- gesso, white (option 2)
- newspapers (option 2)
- newsprint or protective surface
- paintbrush, 1" (25mm) flat
- stencils, stamps or masks
- washi paper, several textures (option 1)

Assorted painted washi papers

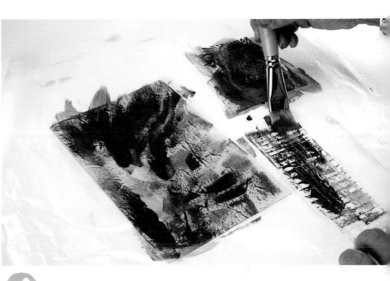

Option 1: Painted Washi Paper

1 Lay out newsprint under the washi paper and dribble fluid acrylic paint and/or ink in colors of your choice across the paper.

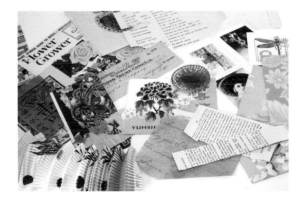

2 Loosely spread paint across the paper.

3 Add pattern using another color of paint and stamps, stencils or masks.

Start your collage paper stash by gathering paper items you may have around the house. Antique stores, garage sales and flea markets are also good for choice collage materials. Collect any type of paper or ephemera— photos, paper bags, junk mail, maps, daily planner pages, stamps, letters, documents, phone books, magazines, catalogs, stationery, wrapping paper, tissue paper, discarded library books, wallpaper.

For additional downloads from the book, go to: www.CreateMixedMedia.com/BoldExpressivePainting

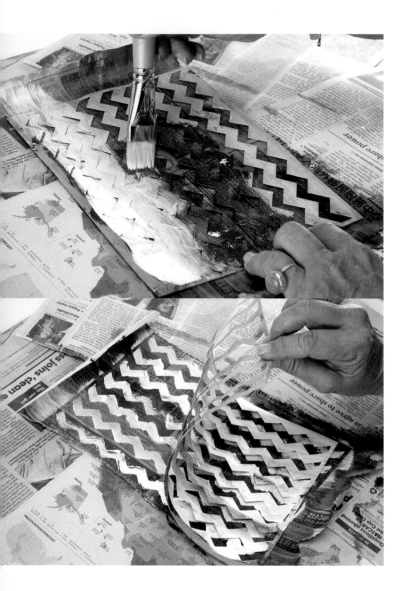

Option 2: Painted Newspaper

1 Begin with newspaper that you've used previously as a protective surface under other painted projects. If you don't have some previously-painted newspaper, start by painting some sheer layers over fresh paper. Add pattern using another color of paint and stamps, stencils or masks.

Assorted painted newspapers

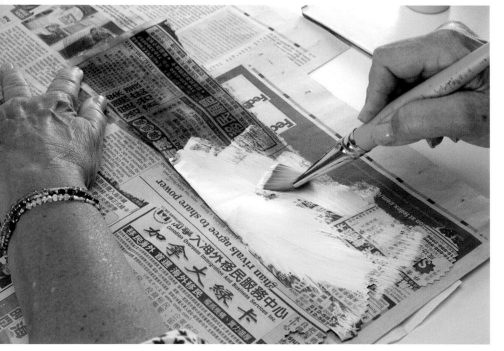

2 You can also paint gesso over the color and come back and stencil or stamp over it when it's dry.

Sign up for our free newsletter at www.CreateMixedMedia.com

Option 3: Gelli Plate Printed Paper

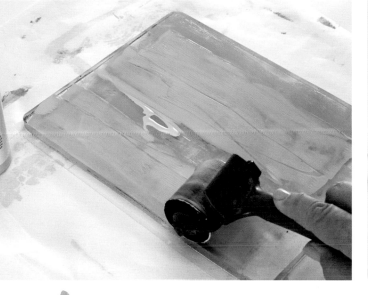

1 Apply fluid acrylic paint to the Gelli surface using the brayer.

2 Lay deli paper on the surface of the Gelli Printing Plate.

3 Smooth the paper with your hand to increase the transfer of paint to paper.

4 Lift the print from the plate and set it aside to dry.

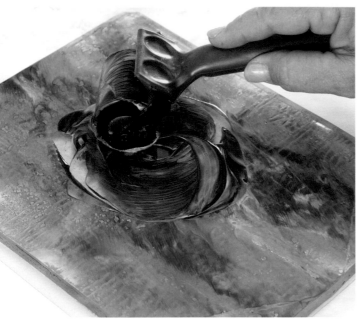

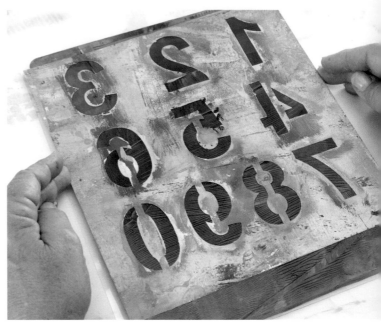

5 Apply a new contrasting color to the plate.

6 Lay a stencil on the plate.

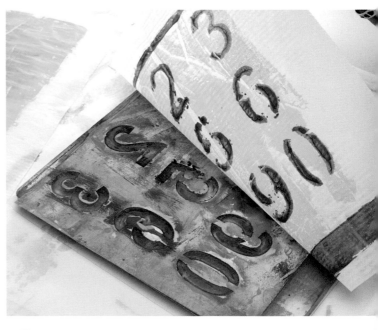

7 Apply the previously painted deli paper to the plate and smooth it to print it again.

8 Pull the printed paper and set it aside to dry.

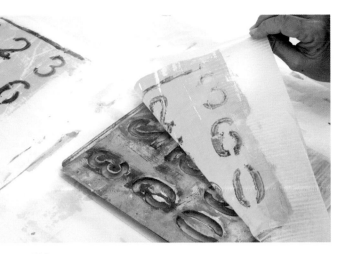

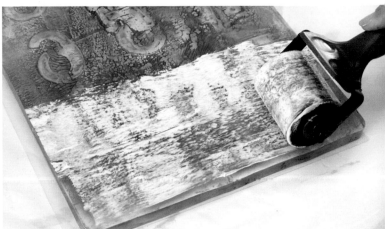

9 Pull another print before the paint dries on the plate.

10 Apply another color of paint to the plate.

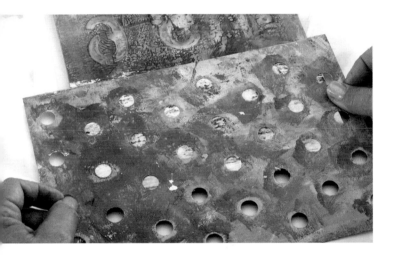

Quick Tip

Remember to clean your Gelli Printing Plate with baby wipes or hand sanitizer before storing in its plastic case.

11 Use another stencil or mask to create even more complexity on the monoprint collage paper.

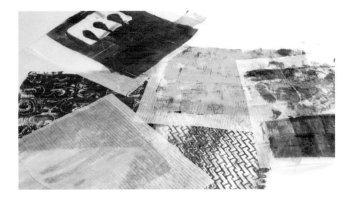

Assorted Gelli Plate printed papers. This entire process should be done very quickly and loosely. Allow to dry and then clip the papers sorted by color together with a Bulldog clip.

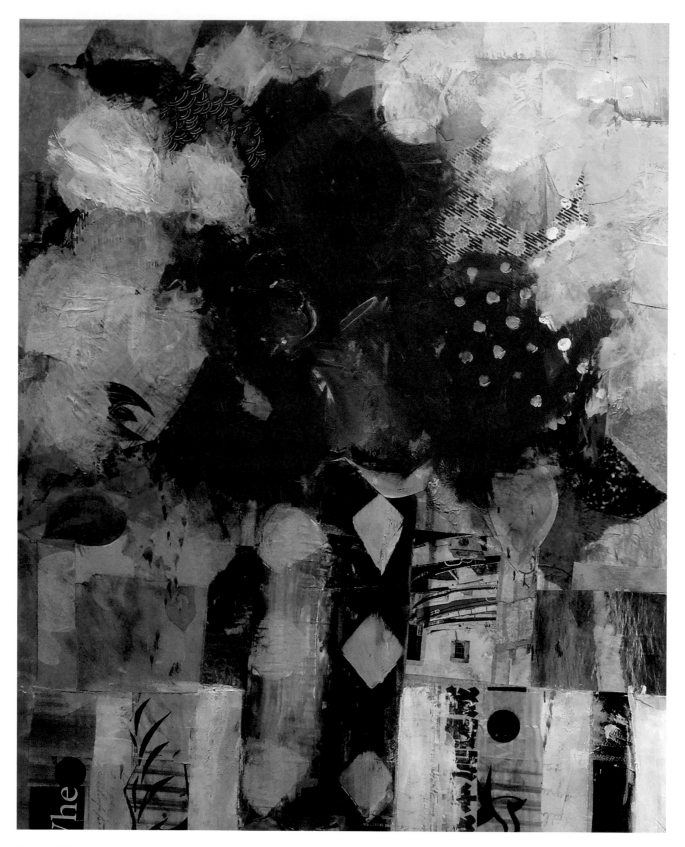

Iris and Roses

*This mixed-media acrylic painting started with a layer
of collage paper and includes stencilling and lots of
intuitive mark-making.*

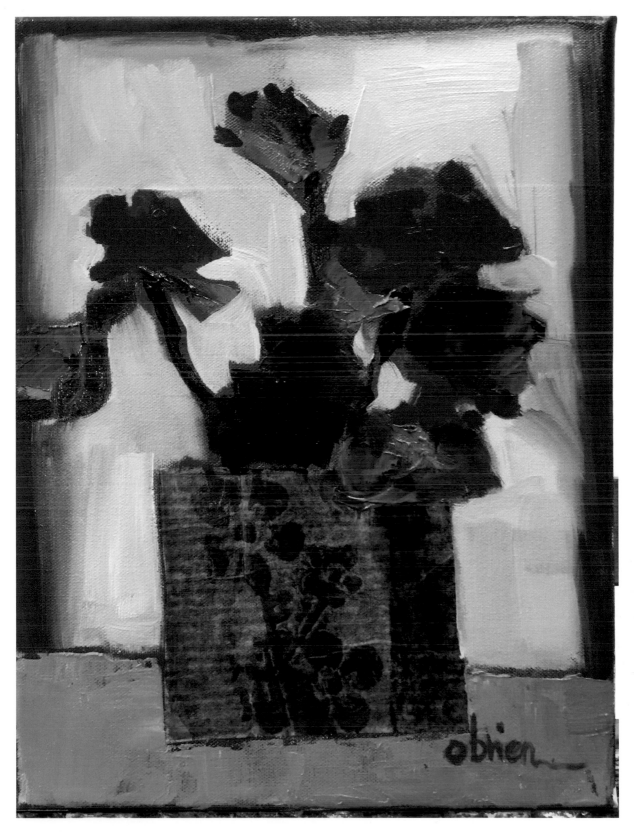

Geraniums in a Blue Pot

The blue pot in this oil painting was created by Gelli Plate printing on dry wax sandwich paper.

Mixed-Media UNDERPAINTINGS

Art is not what you see, but what you make others see.

—Edgar Degas

This technique for creating a mixed-media underpainting can be used for acrylic or oil mixed-media paintings. Keep in mind that if you want to use both, acrylic always needs to be beneath oil paints. If you add an oil-based substance (oil paint, oil sticks, etc.) on an acrylic underpainting, you cannot go back and add additional acrylic materials; oil must always be on top.

This technique serves two purposes: It will loosen you up for a painting session and create a more interesting surface than a single-color underpainting.

Turn on your favorite up-tempo music for this process; you need to have some rhythm and momentum to get this going! Don't think—just have fun layering surfaces. Remember, most of the underpainting will be covered up, but it will provide character for your painting.

What You Need

- bristle brush, 1" (25mm), inexpensive
- drawing tools, your choice (chalk pastels, water-soluble crayons, various pencils, graphite, charcoal, etc.)
- mark-making tools, your choice (scrapers, brayer, scrubbers, credit cards, sticks, etc.)
- medium: fluid acrylic matte
- optional collage material (painted newspaper, washi paper, art tissue, magazine pages, junk mail, vellum, Mylar transparencies, photocopies, watercolor paper, maps, text, magazines, printed papers, etc.)
- paint: fluid acrylic
- paper towels or rags
- stencils
- surface: heavy watercolor paper, Gessobord, illustration board or other rigid surface
- water spray bottle
- water container

1 For the first layer, randomly squirt fluid acrylic paint in splotches on the surface and spread around randomly with a scraper, large brush or brayer, creating some areas of mixed color.

2 Do the same with one or two more colors of fluid acrylic paint.

3 Begin to use mark-making tools—pencils, pastels, crayons—to randomly create marks on the surface.

4 Lay a stencil on top of the surface and apply paint randomly with a brayer.

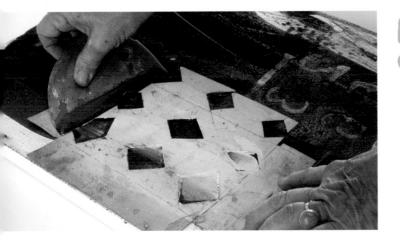

5 Continue to apply paint with stencils at random. (A spreader is an alternative to a brayer when using stencils.)

For additional downloads from the book, go to: www.CreateMixedMedia.com/BoldExpressivePainting

6 Continue using marking tools and stencils until the piece is complex and the surface makes you happy.

7 Add collage paper at random using acrylic medium.

8 Add some marks with a water-soluble crayon.

9 Spritz with water.

10 Blot with a paper towel to remove some of the paint and create even more texture.

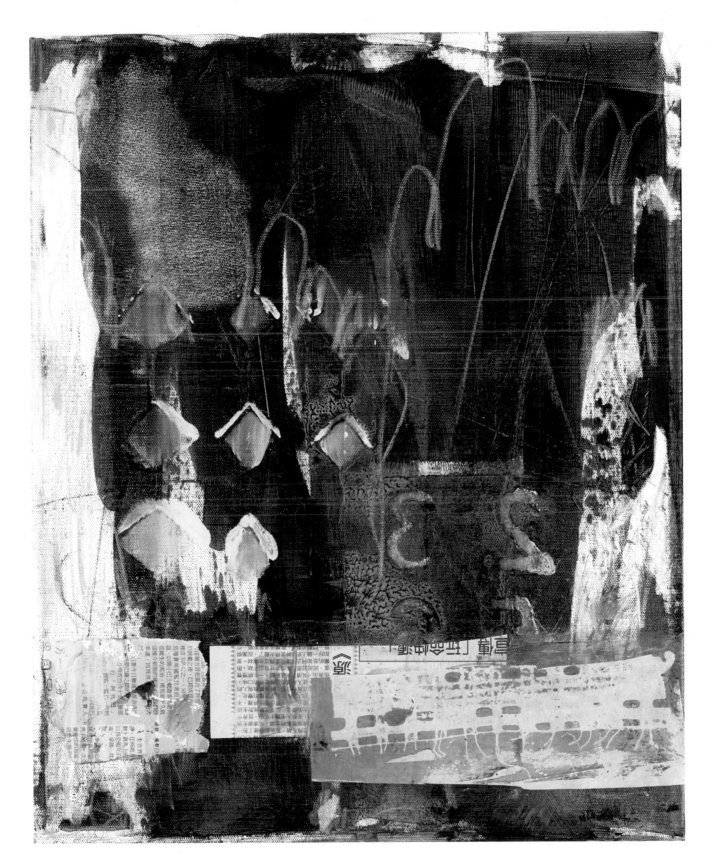

Mixed-media underpainting

STILL-LIFE
Collage Study

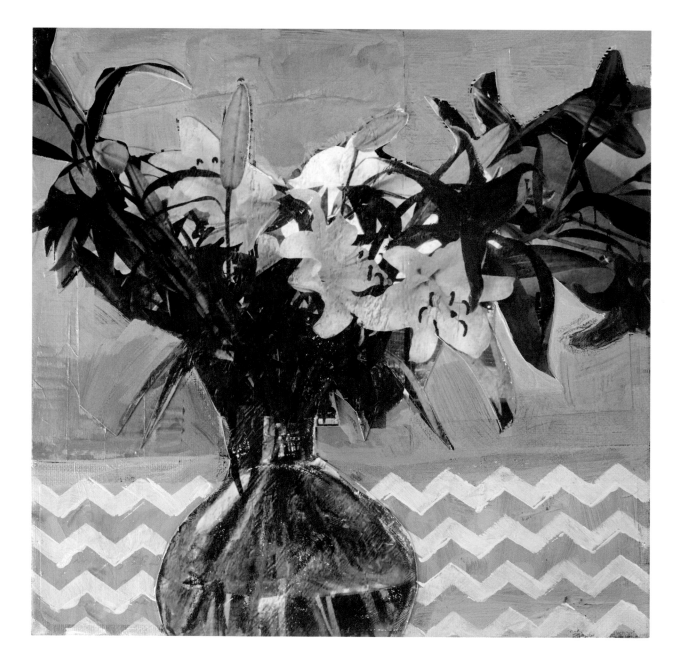

Still-life paintings are a natural for using the collage techniques described in Technique 17. I recommend creating many small still-life studies using mixed media, trying out many mixed-media techniques and materials. In this particular study, I printed a photo of a still-life setup and actually incorporated it as collage material into the painting.

What You Need

- brayer
- bright brushes, ½", 1", 2" (13mm, 25mm, 51mm)
- collage paper pieces
- colored pencil or pastel stick, light color
- medium: acrylic matte
- paint, acrylic: color scheme of your choice
- paper towels or rags
- stencils
- substrate: panel, 18" × 18" (46cm × 46cm) or larger
- water container
- wax paper

1 Paint the support surface with a thin transparent underpainting in a color of your choice; allow everything to dry.

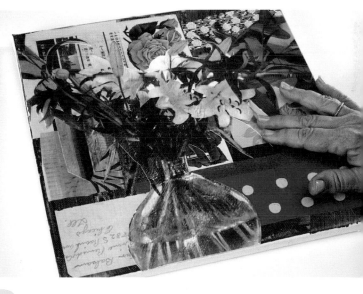

2 To create texture and variety, adhere collage paper pieces to the panel using acrylic matte medium. Add a main focal image. Lay wax paper over the piece and lightly roll with a brayer to release air bubbles and create a firm attachment. Allow things to dry slightly.

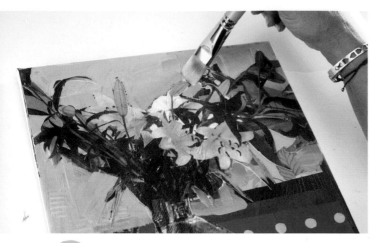

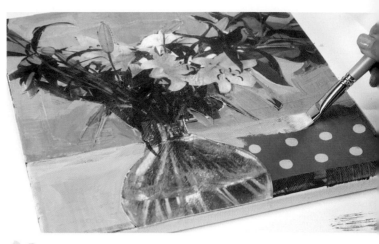

3 Paint the background around the central image.

4 Continue painting in the background by creating a tabletop in a contrasting color.

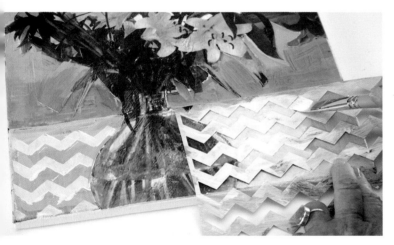

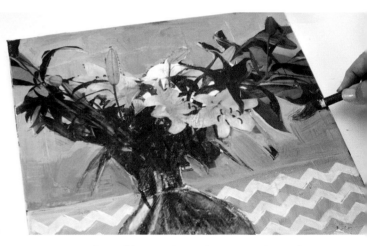

5 Add visual texture by stencilling areas of the background.

6 Use mark-making tools such as pastels and colored pencils to add more visual interest to the central image.

7 Cover the entire image with acrylic medium to ensure the collage adheres to the surface.

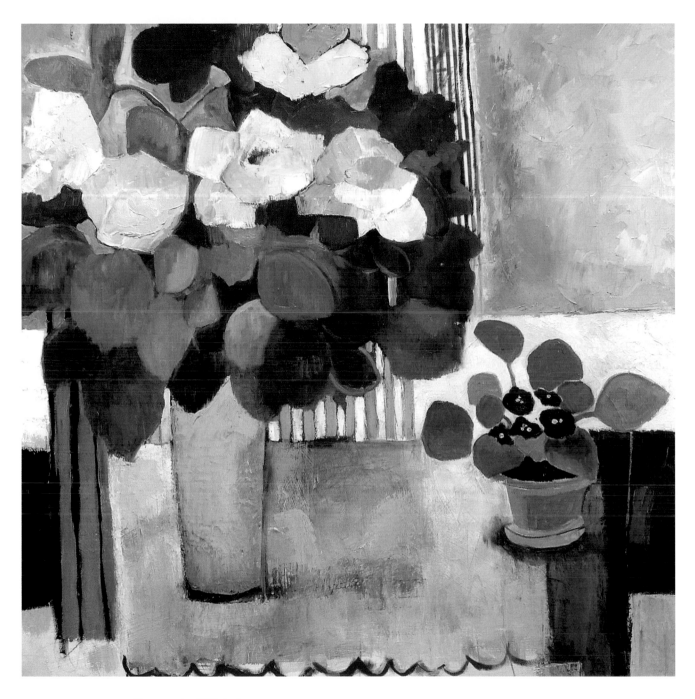

Bouquet of Violets

This mixed-media painting demonstrates the use of several techniques including several types of paper collage as an underpainting, water-soluble pencils, charcoal, acrylic paint and pastels.

MIXED-MEDIA
Still—Life Painting

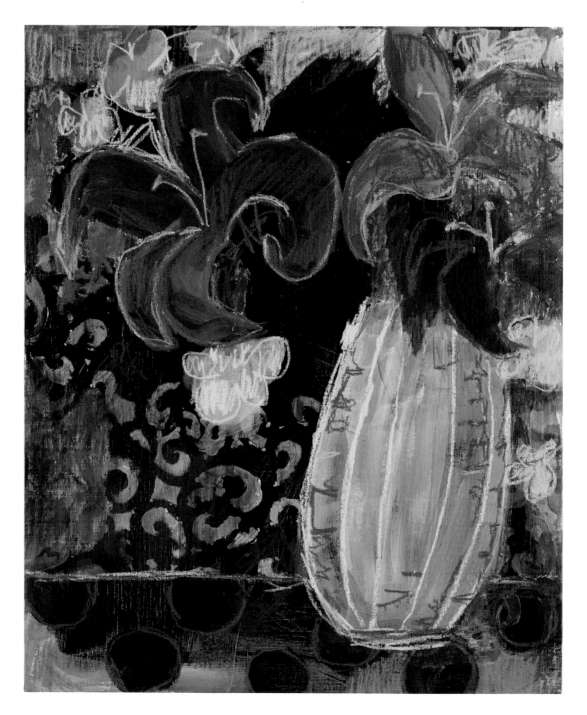

This mixed-media study is intended to give you an opportunity to play with lots of tools and materials. Stay loose, work fast and keep your hand moving to the music, not worrying about results. The idea is not to create a masterpiece the first time you try it but to create lots of studies, trying out various methods of applying paint and making marks. Try to complete this project in 15 to 20 minutes—fast and loose!

What You Need

- ☐ Caran d'Ache or Neocolor crayons
- ☐ colored pencil or pastel stick, light color
- ☐ bright brushes, ½", 1", 2" (13mm, 25mm, 51mm)
- ☐ disposable palette sheet
- ☐ inspiration image (photos or magazine image or a simple still-life setup)
- ☐ medium: acrylic matte
- ☐ paint, acrylic: color scheme of your choice
- ☐ paper towels or rags
- ☐ small squeegee or rubber bowl scraper
- ☐ stencils or stamps
- ☐ substrate: panel, 18" × 18" (46cm × 46cm) or larger
- ☐ water container

1 Begin your underpainting with the approach demonstrated in Technique 17. Apply a couple of colors of fluid acrylic paint randomly to the painting surface.

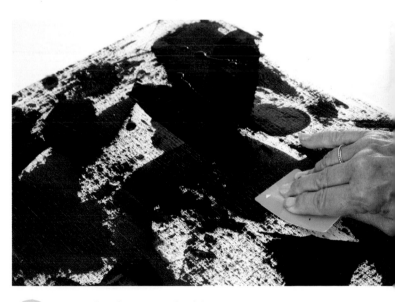

2 Spread paint around with squeegees or scrapers.

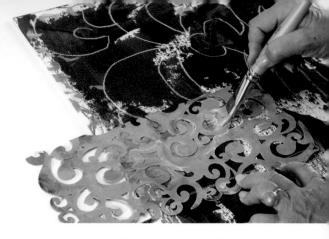

3 Use water-soluble crayons to make random marks throughout the surface. Try to find some images in the random splotches of paint with your crayons.

4 Choose some stencils or stamps and add a third color variation on the surface to enrich the background.

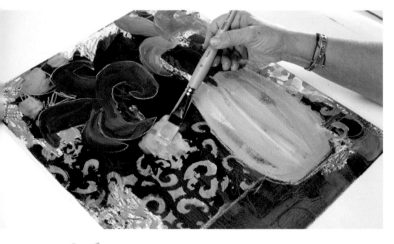

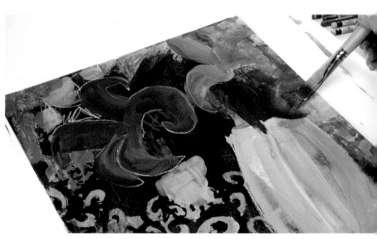

5 Begin to add color to the shapes you found in the background. Make them quirky to stay away from realism.

6 Continue to add variations of value and color to your found images.

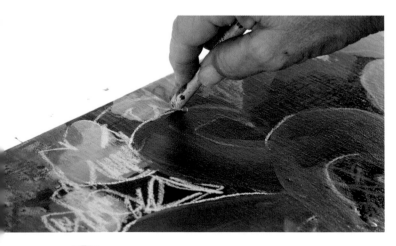

7 Add some other pencil and/or crayon marks to define your images.

8 Keep adding color and value variations and push the image as far as you can. When you run out of steam on this one, do another!

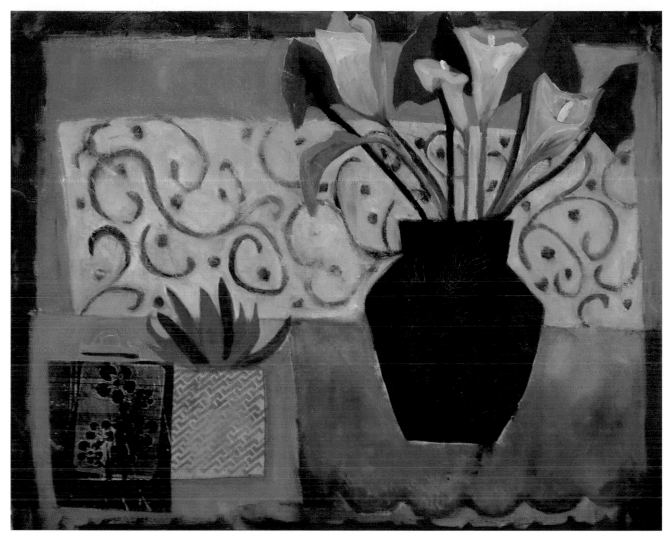

Dragon Flowers

This acrylic mixed-media painting incorporates a loose intuitive underpainting, stencilling, found and created collage papers, and the use of pencil and crayon marks.

Quick Tip

Feeling stuck? When you get stuck for what to do next, it means you should let the painting sit and come back to it (perhaps the next morning) with fresh eyes to see what it needs.

When you return to the painting, step back and take a long look, squint your eyes and decide what areas still need work or where you can add an extra touch of color or pattern to create interest. Consider adding additional texture with stencils, masks or marks.

MIXED-MEDIA
Abstract Oil Painting

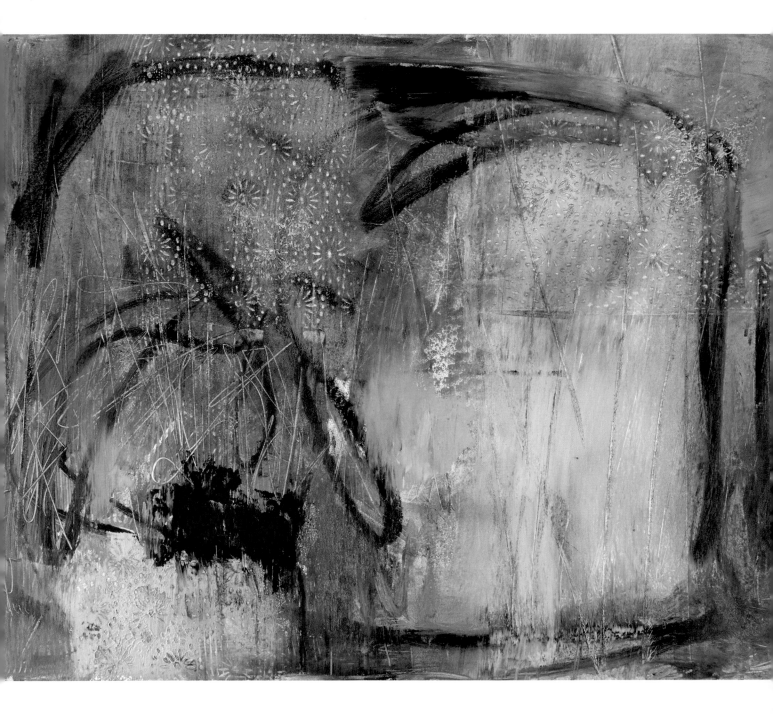

 Sign up for our free newsletter at www.CreateMixedMedia.com

Mixed media is not just for acrylic painting. There are a variety of beautiful options for including mixed media in an oil painting. Here are some basic techniques for experimentation with mixed-media oil painting.

What You Need

- ▢ brayer
- ▢ disposable palette sheet
- ▢ Gamblin cold wax medium
- ▢ Gamsol odorless solvent
- ▢ gloves (optional)
- ▢ mark-making tools such as spatulas, old credit cards, sticks, squeegees, scrapers, sticks, pencils, charcoal, oil sticks, stencils, dish scrubbers, textured paper, fiberglass mesh, Bubble Wrap, fabrics, netting
- ▢ oil paints: your choice of palette
- ▢ oil sticks or oil pastels
- ▢ palette knife
- ▢ paper towels
- ▢ powdered pigments
- ▢ substrate: Gessobord, other rigid support panel or Arches oil paper, 18" × 18" (46cm × 46cm) or larger

1 Scoop about a tablespoon (15ml) of cold wax onto your palette paper. Mix an equal amount of oil paint with the cold wax using a palette knife until the combination is well mixed, light and fluffy. The consistency will be like cake icing.

Begin to spread paint/wax mixtures onto your board. Use scrapers, squeegees or brayers to spread the paint across the panel. Don't think too much, just do.

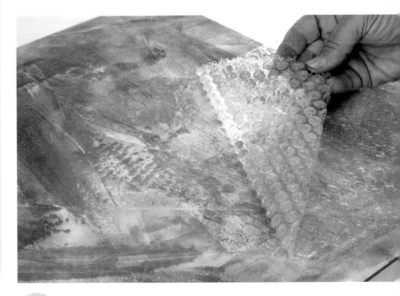

2 Alternate adding more paint with mark making. Scrawl with oil sticks or pastels, make pencil marks, use your scrapers to draw lines through the paint, press Bubble Wrap into the wet mixture . . . anything that comes to mind.

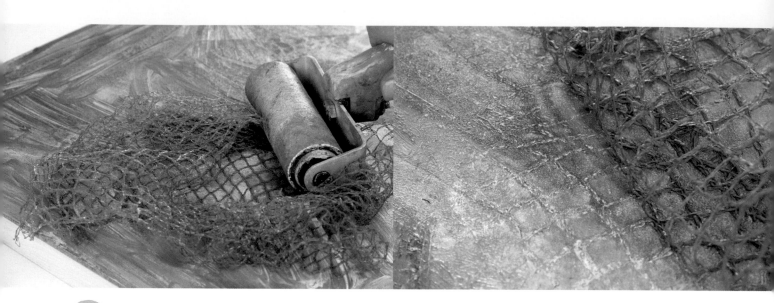

3 Create texture using fabrics, netting or other textured materials and use a brayer to embed them into the oil paint surface.

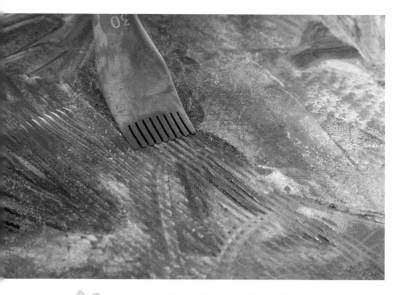

4 Scrape through the paint with tools to create marks.

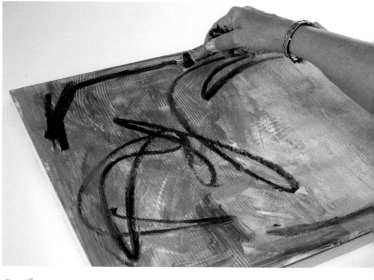

5 Apply marks with oil sticks.

6 Create marks using scrapers.

7 The combination of oil and wax will cause the pigment powder to adhere to the painting as you spread it across.

8 Spread the dry pigment across the surface of the painting with a bowl scraper.

9 Allow the painting to dry to the touch and add a thin layer of cold wax to seal the surface.

For additional downloads from the book, go to: www.CreateMixedMedia.com/BoldExpressivePainting

INTUITIVE PAINTING

This process is intuitive. There's no way to prescribe how to do it exactly; you just have to try it and go with your intuition. Starting without a plan and responding to gestures and happy accidents can lead to some dynamic expressive results. If you put judgment and thinking on hold, this style of intuitive painting encourages your subconscious mind to take over the job of painting. Cajoling the brain to let go can be tricky, but try listening to your favorite feel-good music or audiobooks. Auditory distraction seems to give the intuitive brain space to blossom.

These paintings demonstrate an intuitive approach to abstract oil painting, utilizing various mark-making tools and incorporating cold wax medium and powdered pigments.

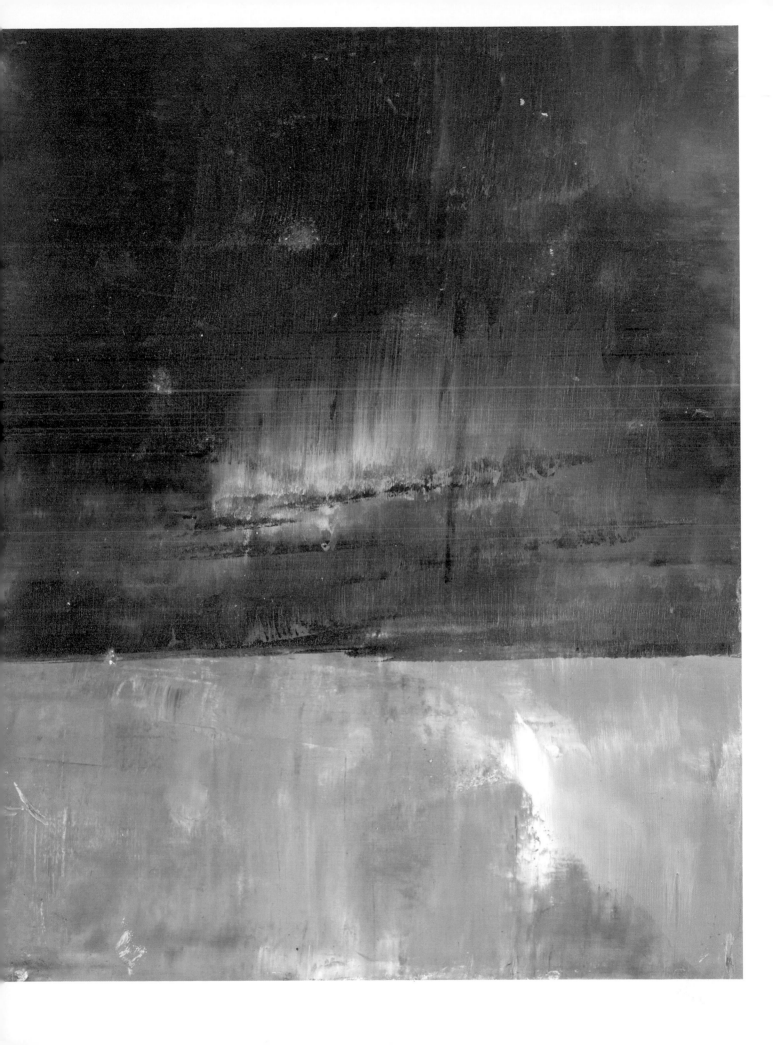

UPCYCLED
Acrylic Painting

"Practice paintings" on paper or even canvas (cut off their stretcher bars) provide great source material for upcycling artwork. You probably have a stack of sketches or paintings that just aren't working or were done as practice that you could use as materials. Give it a try; there's something satisfying about transforming pieces that have been relegated to the closet or under the bed into something exciting.

Vary this technique with your own geometric compositions. This project is just a starter idea; you will think of lots of ways to turn your old work into new and exciting pieces.

Consider adding color and marks with pencils and water-media crayons or covering an entire piece with a glaze made of gel matte medium and a small amount of acrylic paint.

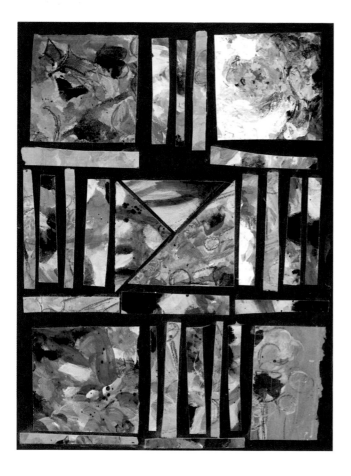

What You Need

- brayer
- bristle brush, 1" (25mm), inexpensive
- medium: acrylic matte gel, gloss (optional)
- Painting Notes sketchbook
- paintings previously created on paper or canvas
- paper towels or rags
- scissors
- substrate, panel or board 12" × 12" (30cm × 30cm) or larger
- water container
- wax paper

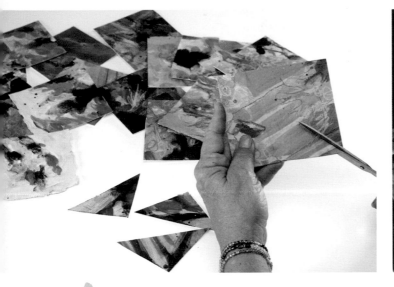

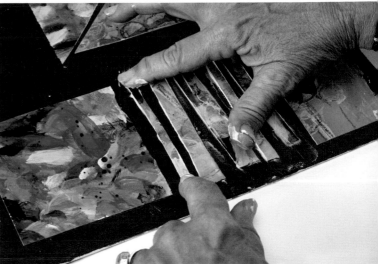

1 Sketch ideas for a geometric design in your Painting Notes sketchbook. Cut recycled artwork into geometric pieces to fit your planned design.

2 Use gel matte medium to attach the largest pieces onto your panel. Once larger pieces are in place, fill in the design with medium and small pieces. Be mindful of color and value but keep the old painting mixed up.

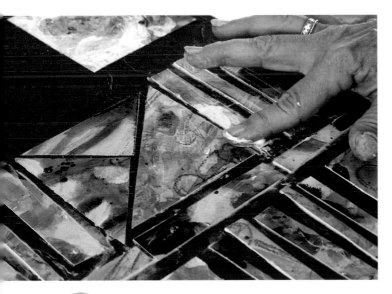

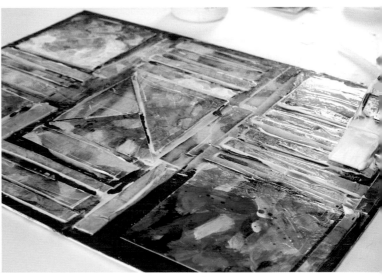

3 Add additional medium to pieces of paper that tend to curl up. One way to get rid of bubbles is to lay a piece of wax paper over the piece and then apply a brayer firmly over all the pieces.

4 Coat the entire collage with a final layer of gel medium—matte or gloss.

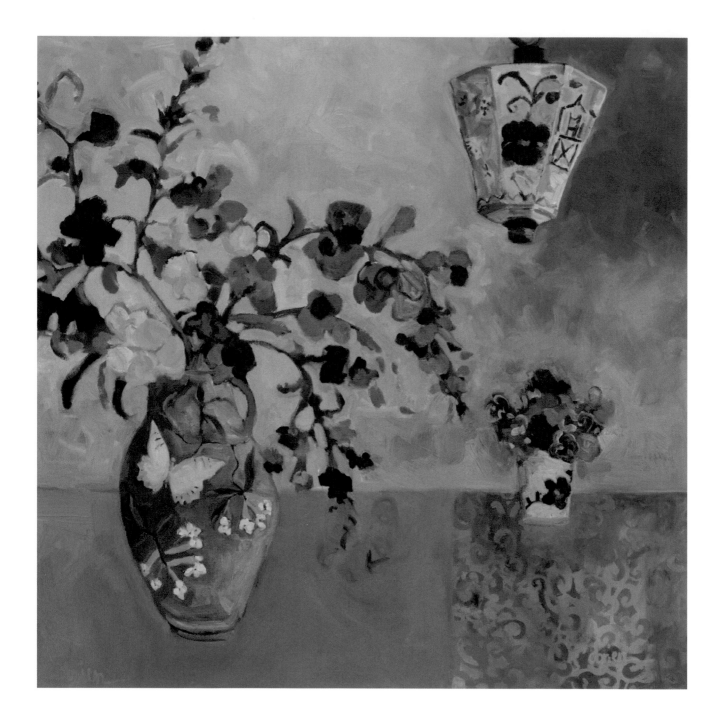

Sign up for our free newsletter at www.CreateMixedMedia.com

CHAPTER 4

FLORAL
Still-Life Painting

Nobody sees a flower—really—it is so small it takes time; we haven't time, and to see takes time, like to have a friend takes time.

—Georgia O'Keeffe

It's no secret: Floral paintings are my favorite. I used to try to avoid doing florals even though I loved painting them. I'm not sure why. I started my flower-painting journey by taking a botanical drawing class. I lasted about two hours. The notion of perfecting the drawing of a dewdrop for a full afternoon was not a good fit for me.

Flowers make me swoon; they always have. I try to use a fresh approach to flower painting and paint the way they make me feel. Van Gogh is one of my heroes when it comes to painting flowers.

As you approach this chapter, remember this style of painting isn't about trying to document nature or create botanical drawings. If your goal is to loosen up your painting style, there is no better subject to practice with than flowers. Turn on some music, place a bunch of flowers in front of you and let go. There is no better way to spend a morning in my humble opinion!

Still life is an old tradition in painting; so old, in fact, that it sometimes is relegated to practice paintings or overlooked as boring and staid. However, let me go on record as saying still-life paintings are also one of my favorites, especially if they include flowers. Still-life painting can be so intimate and almost voyeuristic—a peek into someone's home or psyche. My challenge to you is to make your floral still-life paintings unique and intriguing.

SETTING UP
a Floral Still Life

The simplest floral arrangement from your garden or local grocery store can serve as inspiration for a floral still-life painting. Throw flowers into an interesting container, spread out a tablecloth or remnant of fabric, grab an unusual personal object or piece of fruit on the table and you are set. Collect interesting objects to place in your still-life setups. Remember to photograph your arrangement to save for days when you don't have flowers available to paint. Decorating and gardening magazines are great sources of inspiration for floral still-life paintings if flowers aren't available. I believe it's useful to try painting from life and from photos. You may also benefit from starting a list of flowers and plants you want to paint, collecting photos from garden magazines of interesting shapes and colors of flowers and adding all of these ideas to your Painting Notes sketchbook.

TIPS FOR PAINTING FLOWERS LOOSELY

- *Simplify shapes—don't paint petals, paint the overall profile of plants and flowers.*
- *Paint the feel or spirit of flowers rather than the details.*
- *Let the flowers speak to you and create an emotion that you can express through your painting.*
- *Work from the still-life setup until the painting decides to take over, then let the painting have its voice and forget the setup.*
- *Make one flower the star and assign the others as supporting players of various sizes. Always use an uneven number of flowers and vary their sizes and the spaces between them. No little "tulip soldiers" marching single file across the page!*
- *Block in shapes loosely in the beginning with the darkest version of their eventual color. Remember, in expressive painting you can create with whatever color pleases you.*
- *Paint flowers larger initially than you intend for them to be since you can cut back into them to create shapes.*
- *Extend your composition off three sides to allow the flowers to breathe.*

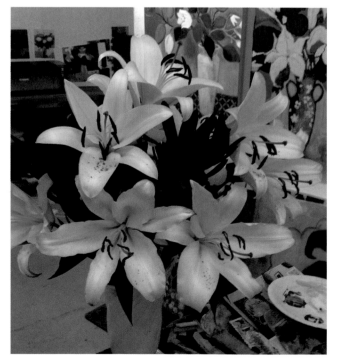

TECHNIQUE 18
PERSONALIZING
Still-Life
Paintings

There are always flowers for those who want to see them.

—Henri Matisse

What You Need

- ▢ assortment of vases you like
- ▢ collection of personal objects
- ▢ fabric remnants
- ▢ magazine clippings and inspiring photos
- ▢ Painting Notes sketchbook

One of my favorite still-life painters is British artist Mary Fedden. Her paintings are a glimpse into her personal world on the Thames River in London. Personal objects—plates, vases, textiles—from her collection rotate through her paintings, reappearing in different still-life setups, making her work an intimate glimpse into her life. Think about the objects that are unique and meaningful to you, whether it is vases you have collected, fabrics you have inherited or flowers you love, and how you can incorporate them into your work.

1 Create your own personal collection of objects to use as references in your paintings.

- Go through your house and/or studio and gather items that are personal and maybe even a little quirky. Start a shelf for these items in your studio or workspace along with beautiful vases for flowers, of course.
- Collect fabrics to use in still-life setups. Remnants at fabric stores, tablecloths on discount or vintage yard sale fabrics are great to cover tables and inspire pattern ideas in your paintings.
- Jot down notes of special things you loved as a child, perhaps toys and perfume bottles, and make small sketches in your Painting Notes as references for paintings.
- Collect photos or magazine clippings that depict still-life settings and put them in your Painting Notes along with notes and sketches.
- Create a couple of pages in your Painting Notes to record patterns you see around you to reference for backgrounds, tabletops and vases in your still-life paintings.

2 Brainstorm a series of still-life paintings that feature favorite objects or flowers in different setups and record your ideas in your Painting Notes.

Adding Texture
TO PAINTINGS

I try to construct a picture in which shapes, spaces, colors, form a set of unique relationships, independent of any subject matter.

—Milton Avery

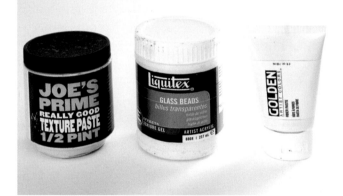

Acrylic floral and still-life paintings lend themselves to the use of texture as a device to add excitement. Texture can be tactile or visual or both. Tactile texture includes anything added to paintings that redefines the painting surface— acrylic mediums, collage materials or innovative marks. Visual texture is created through the use of pattern. The following texture techniques add interest and personality to paintings.

What You Need

- art tissue paper, patterned wallpaper or other collage paper
- brayer
- bristle bright brushes, 1" (25mm), 2" (51mm)
- mark-making tools
- mediums: acrylic matte and one acrylic specialty medium such as molding paste, glass bead gel, clear tar gel or pumice gel
- paint: acrylic palette of your choice (fluid transparent Iron Oxide acrylic paint works great)
- palette knife
- paper towels
- stencils, assorted
- surface: several panels at least 12"× 12" (30cm × 30cm), pretreated with gesso (Note: MDF works well for practice panels.)
- water

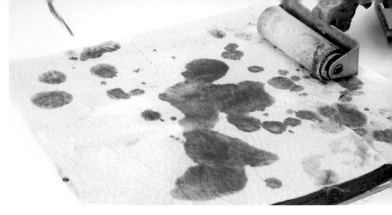

1 Underpaint the panels with a thin coat of a transparent acrylic color of your choice. While the paint is wet, sprinkle on some water in a few places.

2 Place paper towels over the panel and roll over the wet paint with a brayer.

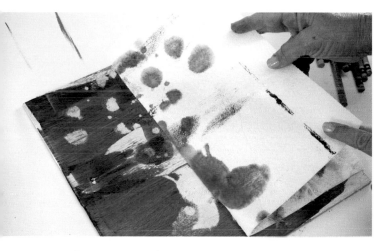

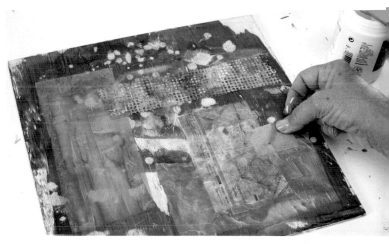

3 Remove the paper towels. Let dry.

4 Apply acrylic medium and then an assortment of torn or cut tissue or collage paper to the panel.

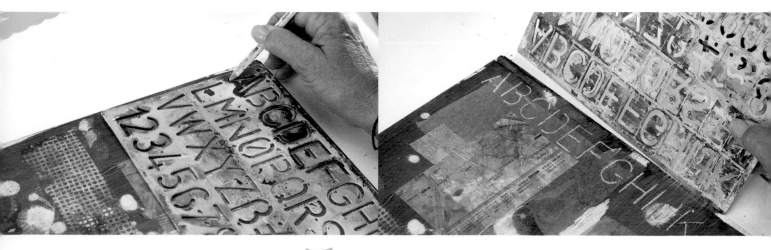

5 Add complexity with marks using pencils, stencils and scratching tools.

For additional downloads from the book, go to: www.CreateMixedMedia.com/BoldExpressivePainting

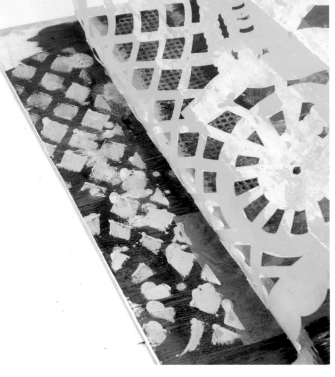

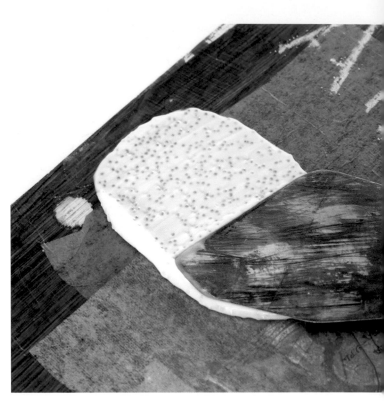

6 Continue to add texture using stencils.

7 Another way to create texture is with specialty mediums such as glass bead gel.

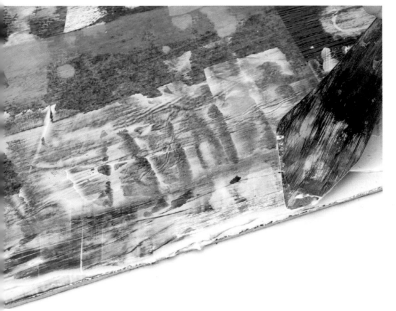

Quick Tip

It's easiest to do several of these panels at the same time, working quickly. Record the techniques you especially love in your Painting Notes.

8 Molding paste can be applied with a palette knife and when dry will leave behind an interesting texture. Allow these specialty mediums to dry before continuing with any additional paint.

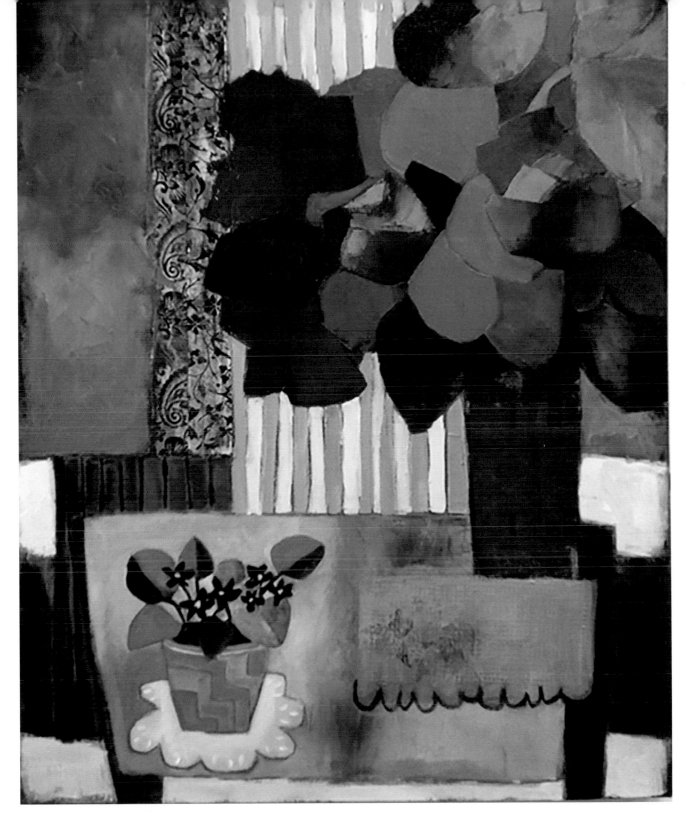

Red Roses and Violets

*This floral still-life painting is part of an ongoing series I have been
working on, which includes vintage containers, collected fabrics and some
of my favorite flowers—violets and roses. It also incorporates just about
everything in my mixed-media tools—paper collage, crayon, pencil,
stencils and paint.*

NEGATIVE Shape Painting

Instead of trying to reproduce exactly what I see before me, I make more arbitrary use of color to express myself more forcefully.

—*Vincent van Gogh*

Negative shape painting is a tool that every painter should learn. It can change a so-so painting into an eye-popping piece. You might try this technique on a painting you're not too crazy about, one that is not bad, but not great. You will feel like you have nothing to lose and be willing to experiment. The idea is to transform the background around the main subject dramatically to create greater contrast to make the painting pop. This is a great exercise to sharpen your eye for shapes, values and colors.

Before beginning painting, step back and take a long look at the original painting and decide what it needs to create a dramatic shift in value and/or color between the main subject and the background. (The problem is usually that everything has leaned toward a middle value.)

In the unlikely event that it turns out that the new background color doesn't work, try again. Remember, you have nothing to lose and this is how we learn—by taking chances.

What You Need

- bristle flat brush, 1" (25mm)
- paint: acrylic or oil in a dramatically lighter or darker color scheme than the original painting
- paper towels or rags
- surface: floral still-life painting that needs work or you're just not happy with—any size
- water container (acrylic) or Gamsol odorless solvent (oil)

1 Mix the background color. Check the value contrast and warm/cool color contrast by holding a brushload of the new color next to the subject matter of the painting.

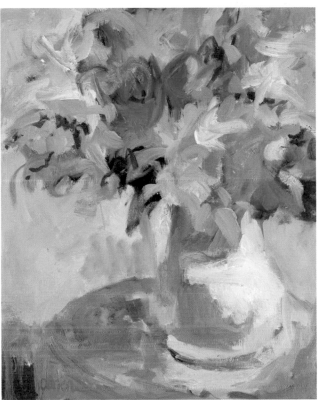

2 Using a flat medium-sized brush, begin the fun of cutting around your design, creating new shapes as you go.

Original painting

3 Don't be afraid to be bold and carve some new shapes into the edges of your subject matter with your background color.

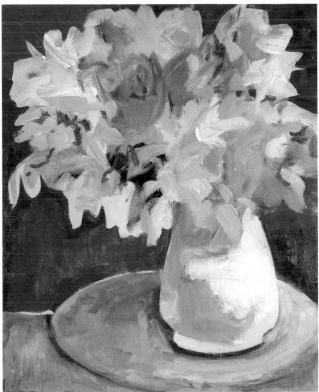

4 Add deeper values to other areas of the painting such as under the vase and the edges of the table to increase contrast and add drama.

Revived painting

Mixed-Media Floral
STILL-LIFE PAINTING

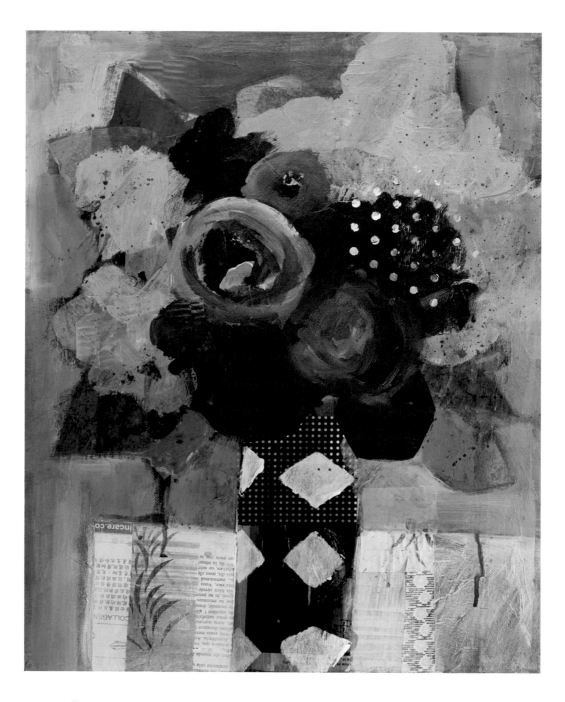

This project incorporates visual and tactile texture techniques described in Technique 19. To begin this painting, set up a simple still life including your favorite flowers in a container, a patterned cloth and an object.

What You Need

- art tissue paper and/or decorative paper scraps
- bristle or synthetic brushes, flat, ½", 1", 2" (13mm, 25mm, 51mm)
- mark-making tools (optional)
- medium: acrylic matte medium
- paint: acrylic in a complementary color scheme plus Titanium White
- Painting Notes sketchbook
- paper towels or rags
- pencil
- stencils
- surface: Gessobord, panel or canvas, 16" × 20" (41cm × 51cm) or larger rectangular
- water container

Quick Tip

A simple still-life setup can consist of a container of your favorite flowers and perhaps an interesting bowl or piece of fruit on a patterned tablecloth. Don't be concerned about setting up strong lighting as in traditional still-life setups since we are painting in an Expressionist style, which is not dependent on the realism of shadow patterns. Work from dark to light color values across the entire painting, bringing all the painting along. Try not to focus on painting individual objects (vases, tables, apples) but rather shapes and colors.

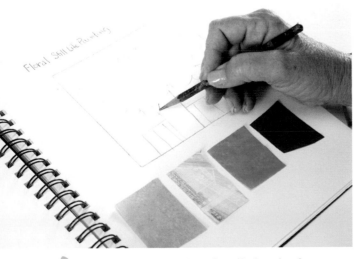

1 Create a vertical thumbnail sketch of your composition and choose a color scheme.

2 Apply a thin transparent underpainting with warm colors and allow to dry.

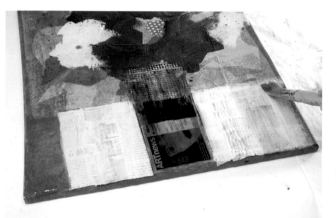

3 Add tactile texture by applying a layer of art tissue paper or other decorative papers with matte medium and allow to dry.

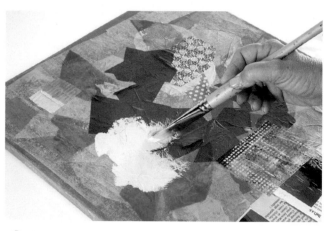

4 Begin to add flowers with paint on top of the collaged paper.

5 Fill in the background and the tabletop with paint using color and value contrast.

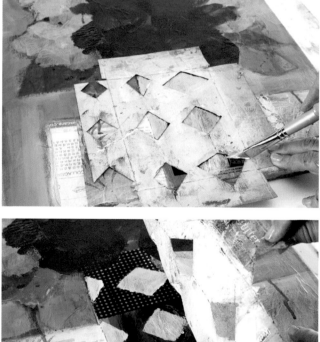

6 Add visual texture with stencils.

Quick Tip

As you create the map of your composition and begin to block in your colors on the shapes, make one flower the star of the composition and vary the sizes, shapes and positions of the other flowers. Odd numbers of flowers read better than even numbers. Stay loose and allow random drips and splashes to occur—don't color inside the lines!

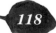

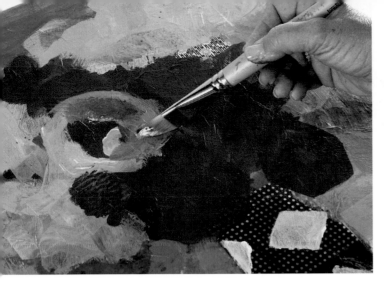
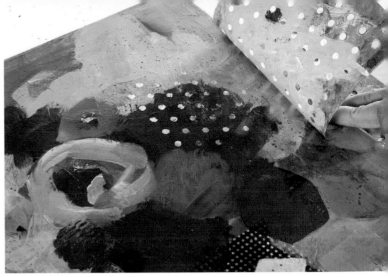

7 Add another layer of paint in a lighter value to add final texture and definition to the flowers.

8 Add pattern details using stencils and/or mark-making tools such as pencils and pastels.

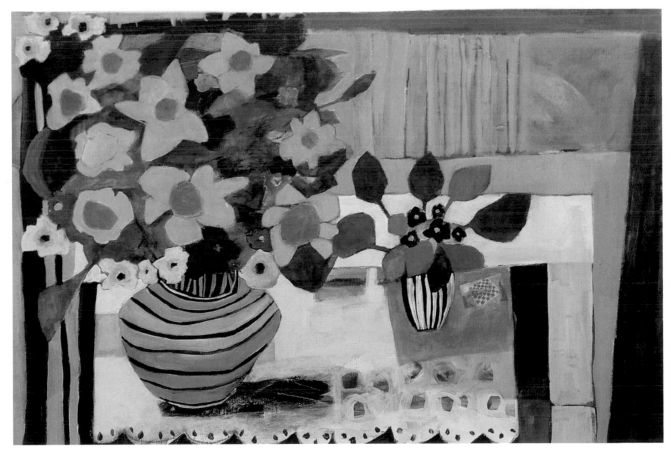

Daffodils and Violets

This painting began with a grid of paper collage including painted washi paper, pages from vintage books and other ephemera. Although it was painted from a still-life setup of real daffodils and violets, I've taken my expressionist liberties with the shapes and colors to make it my own.

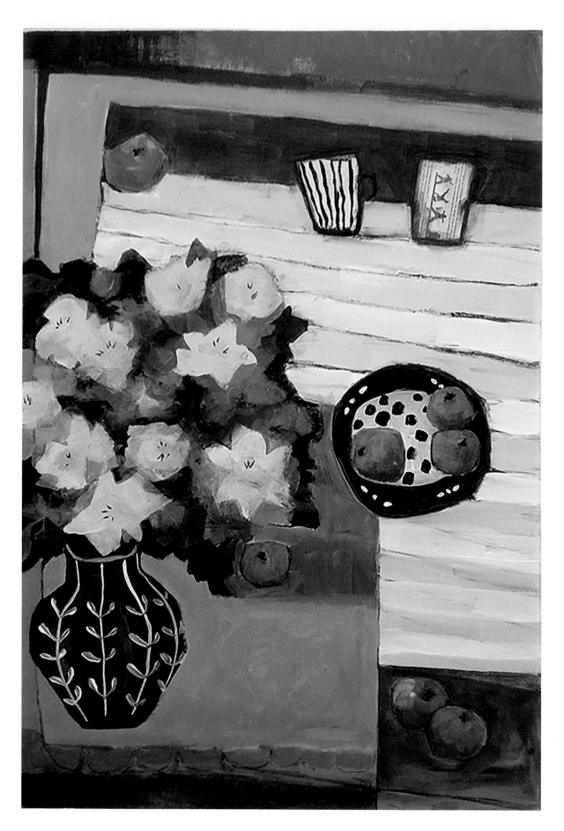

Daffodils and Mandarins
This painting includes collage, lots of mark-making with various tools and an unusual expressive perspective on a still-life setup.

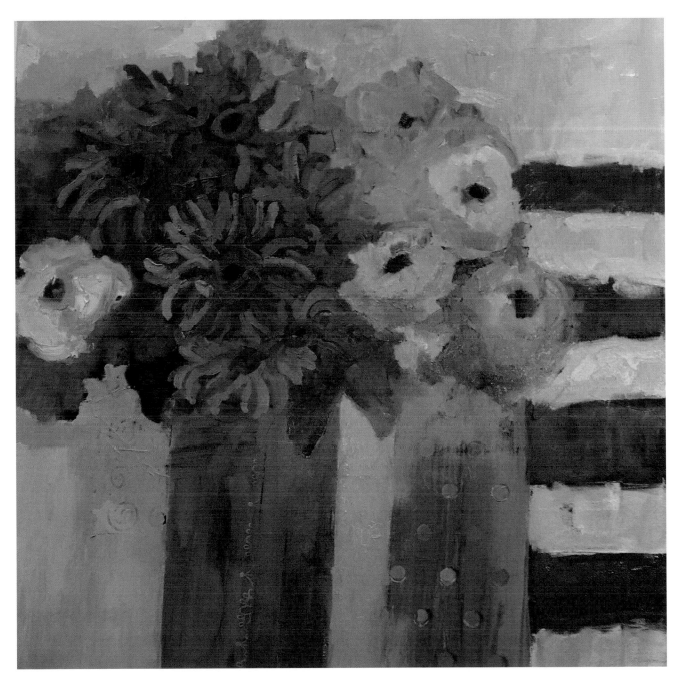

Dahlias and White Roses

*This painting started with a layer of
collage paper and added layers of
stencilling and mark-making done
in a contemporary color scheme.*

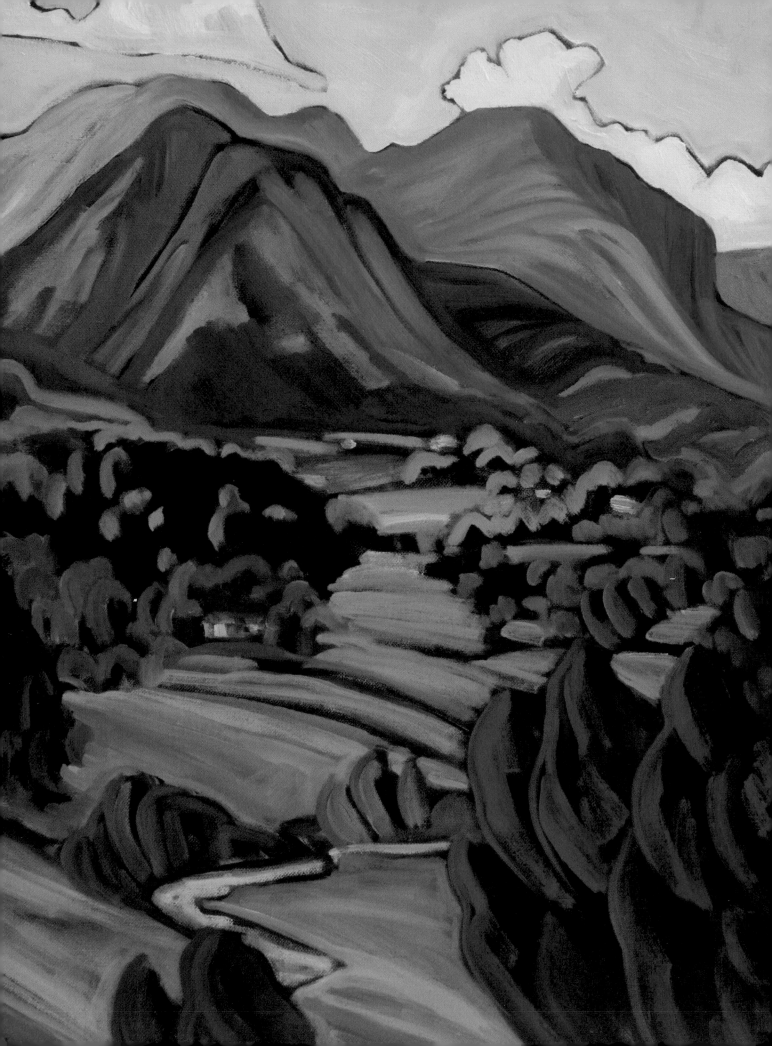

Loose Expressive LANDSCAPES

I had to create an equivalent for what I felt about what I was looking at—not copy it.

—Georgia O'Keeffe

Landscape painting . . . now there's a subject matter with a lot of wonderful painters, especially where I live. I love to paint outside here in New Mexico. I recommend that everyone try it even if you decide it's not for you. It will sharpen your eye for the colors and forms of the landscape.

Landscape painting is an area where expressive painters can really be creative. You have to be judicious about what you read and who you compare yourself to because most landscape painting books are written for realistic, impressionistic or plein air landscape painters. I've learned to stop comparing myself with other landscape painters, and I try to capture the excitement and love of the landscape that I feel and in the style that works for me.

One of my favorite contemporary painters who paints his home landscape in an expressive manner is British painter David Hockney. After many years of living in California, this Yorkshire native returned to the area where he was born to capture the glowing greens of rural England on ultra-large landscapes, all done outside. To get fired up about the potential of landscape painting, I recommend watching the videos of Hockney painting on six large canvases at once on a muddy rural road!

Landscape paintings can be done en plein air (French for outside) from photographs and sketches or frequently from a combination of all of the above. One approach, if you prefer to paint in your studio, is to go out on a sketching/ photographing expedition of the landscape to experience it. Make quick sketches (which encourages the eyes to really look) to design compositions you want to paint and take reference photos that capture a reminder of color inspiration to bring back to the studio. Of course, as an expressive (as opposed to realistic) painter you can rearrange all of these as you wish them to be when you get back to the studio.

Painting Outside the LANDSCAPE BOX

Enjoyment of the landscape is a thrill.

—David Hockney

Most landscape paintings are composed as horizontal rectangles, but there are several other possible composition options you might want to try. Indeed, any horizontal abstract painting tends to read as a landscape because our brains are so conditioned to read horizontals as horizons. For this reason, abstract painters avoid painting horizontals sometimes. Landscape paintings are usually painted with three distinct spatial divisions: foreground, middle ground and background. By changing the shape of the canvas and the distribution of these three spatial divisions, you can create interest and break out of the traditional landscape composition.

For this exercise we'll be doing three studies: a square format, a vertical format with a high horizon line and a vertical format with a low horizon line.

What You Need

- bristle bright brushes, ½" (13mm), 1" (25mm)
- landscape reference photo
- paint: acrylic or oil paint palette of colors in a complementary color scheme plus Titanium White
- Painting Notes sketchbook
- paper towels or rags
- pencil
- surface: rectangular canvases or panels, 2, your choice of size; square canvas or panel, your choice of size
- water container (acrylic) or Gamsol (oil) odorless solvent

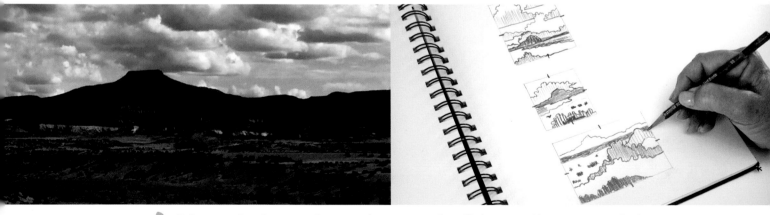

1 Select one landscape reference photo to use for all three studies. In your Painting Notes, create sketches of three versions—a square format, a vertical format with a high horizon line and a vertical format with a low horizon line.

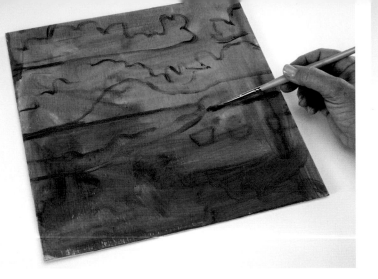

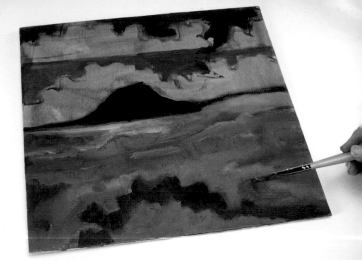

2 Begin with the square surface. Using your square sketch as a guide, paint an underpainting for the background and let it dry. Next, create a map of three to five large shapes.

3 Begin to add the first layer of color by adding the darkest values across the composition.

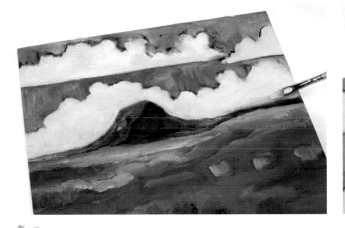

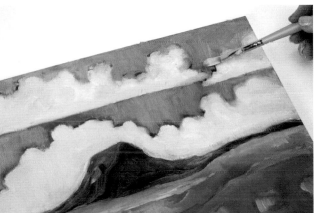

4 Add lighter colors to the painting.

5 Add another layer of color to the entire surface, paying attention to maintaining color and value differences.

Next, paint the same landscape image on a vertical rectangle with a high horizon line and another vertical with a low horizon line. Compare your three versions of the same landscape image.

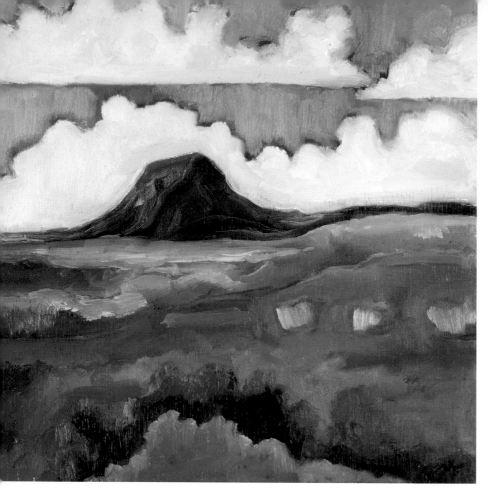

Square Format Landscape Painting

Square landscape compositions are unusual and can be very challenging to paint, but they also appear more contemporary because they were seldom used by the Old Masters. If you want to paint a very modern landscape painting, try painting it on a square support. Check out the square format landscape paintings of none other than J.M.W. Turner, a British master painter in an era when square compositions certainly were not common. His square format landscape paintings were on exhibition recently at the Tate Gallery in London. In 1846, when they were painted, the square format landscape was so radical that one critic described them as "indicative of mental disease." How's that for "out of the landscape box?"

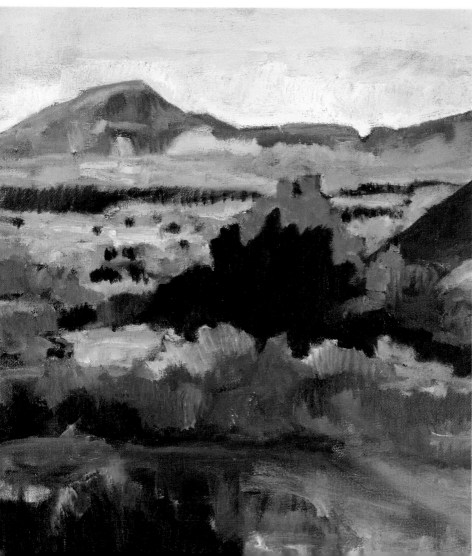

Vertical Format with Large Foreground, Small Middle Ground and Background

Raising the horizon line to the upper third of the painting creates an interesting landscape composition with a dominant foreground, which makes it unusual. An example of a masterpiece painting done with this composition is Vincent van Gogh's painting of an almond orchard titled The Flowering Orchard, *1888.*

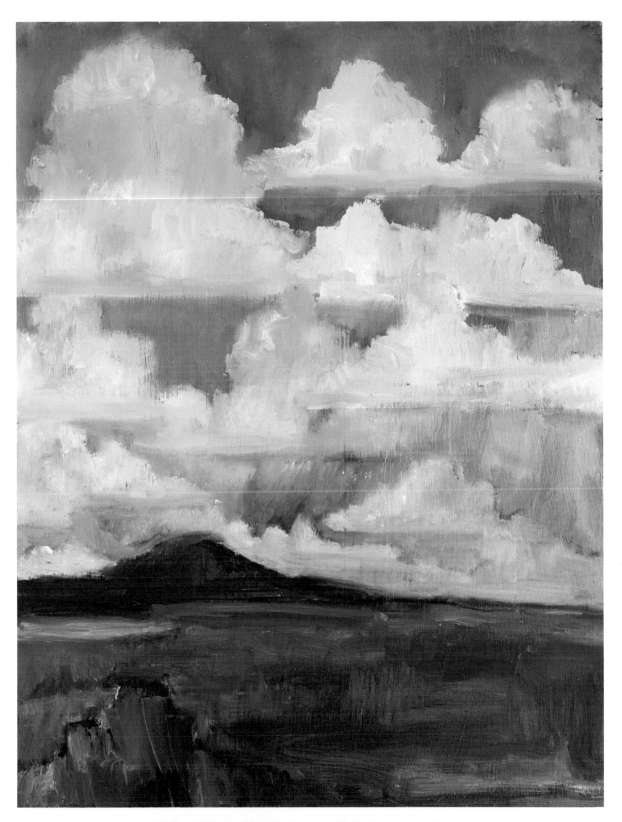

Vertical Format with Small Foreground, Small Middle Ground and Large Background

If you prefer to create a focus on clouds or sky, consider composing the foreground and middle ground into the lower third of the painting, leaving the upper two-thirds as background (sky).

TECHNIQUE 22

GLAZING
a Painting

Creativity is just connecting things.

—Steve Jobs

What You Need

- ☐ medium: acrylic glazing liquid
- ☐ paint: fluid acrylic in any of the following colors—Nickel Azo Yellow, Nickel Azo Gold, Transparent Red Quinacridone, Iron Oxide, Transparent Phthalo Blue (Green Shade)
- ☐ paint rag
- ☐ previously created acrylic painting—preferably one that needs something
- ☐ small cup (yogurt containers work well)
- ☐ soft brush, 1" (25mm)
- ☐ water

Glazing paintings is a nifty technique that can really save a very "blah" painting. When you just can't think of what to do or you have given up on a piece, try glazing it and see what happens. You will be surprised by the abrupt change it creates. You can practice on paintings you have relegated to the "just not working" shelves to get a feel for glazing. In the following technique I suggest paint colors that I typically use for glazing. Choose one depending on whether you want the painting to lean toward cool (blue) or warm (yellow or red). You also may want to experiment with using other transparent colors for glazing.

1 Mix a small amount of the paint color of your choice with a larger amount of matte medium in a small cup. The amount needed will depend on the size of the painting, but lean toward a smaller amount; you can always mix more.

2 Apply the mixture to the painting with a soft brush across the entire canvas.

3 If the color is too intense, immediately wipe the painting with a wet cloth to lighten the glaze. Let dry.

LANDSCAPE
Collage Painting

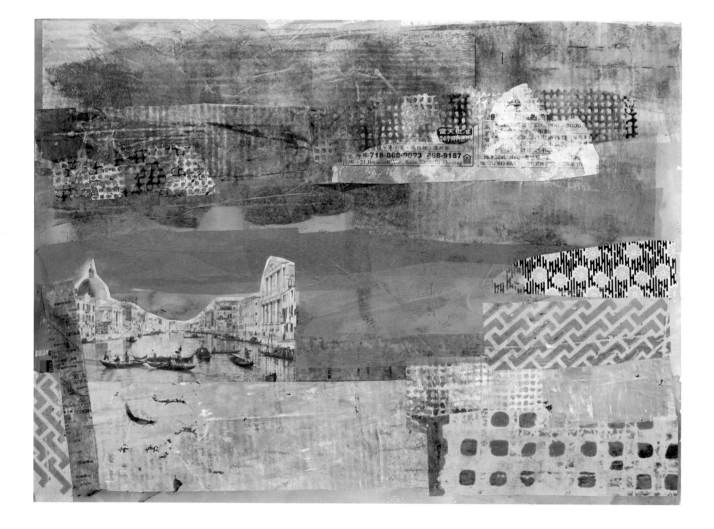

What You Need

- brayer
- bristle or synthetic flat brush, 1" (25mm)
- collage papers in analogous colors
- medium: acrylic matte
- paint: fluid acrylic in analogous colors
- Painting Notes sketchbook
- pencil
- reference photograph of landscape scene (optional)
- surface: panel or heavy watercolor paper, 11" × 14" (28cm × 36cm)
- water container
- wax paper

Landscape collages are really fun to do and a great exercise even if you don't plan to use this technique for every painting. The linear nature of paper collage lends itself to landscape painting and adds surprising texture and interest. This project is done with acrylic paint and medium in an analogous color scheme.

Quick Tip

After the piece is dry, add marks with colored pencils or water-based crayons. You might also glaze it by covering the entire painting with a mixture of a small amount of a transparent color and acrylic gloss medium.

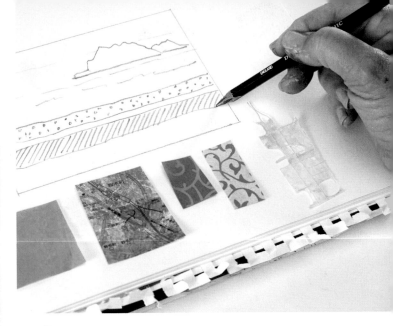

1 Do a quick thumbnail sketch of a simple landscape scene in a format of your choice in your Painting Notes sketchbook. You can dream one up or use a magazine photo or your own photo for inspiration. Decide where to locate the horizon line and how to divide the space between background, middle ground and foreground, and mark those on your thumbnail sketch. Choose an analogous color scheme as well.

2 Prepare the panel or paper by underpainting with thin transparent acrylic paint in one of your chosen colors and allow to dry.

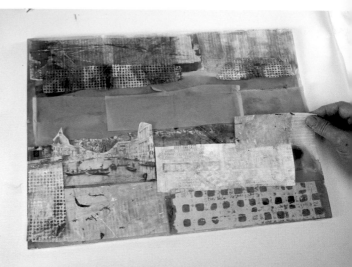

3 Decide on three colors of paint and collage paper in your analogous color scheme. Be sure to select collage paper in three values: dark, medium and light.

4 Tear or cut the collage paper into strips of varying widths and values. Lay out strips in various shades of the color scheme to determine what works to suggest a landscape.

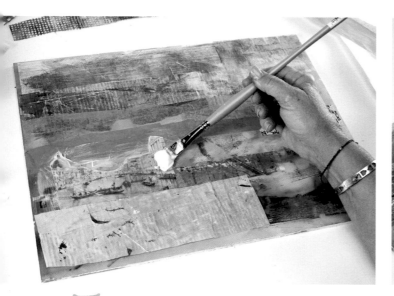

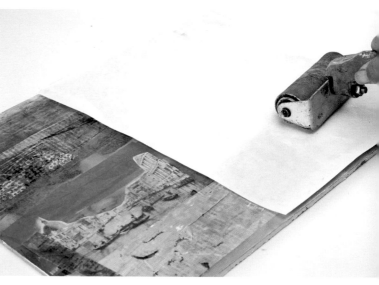

5 Once you arrive at a layout that works, begin to glue the collage paper to the support using matte medium. (Top down works best for most landscape collages.)

6 Add additional layers of paint including foreground and shapes in the setting—trees, mountains, etc.—to enhance the composition, paying attention to value and color variation to add interest. When all the collage paper has been glued to the support, place a sheet of wax paper over the collage and roll it firmly with the brayer to ensure tight cohesion of paper to support and allow it to dry.

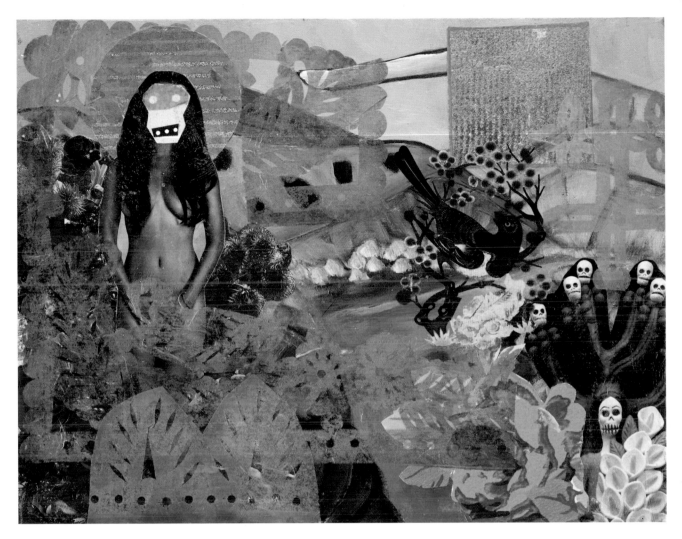

Dia de los Muertos

*This simple collage was created by adding paper over an unsuccessful
landscape painting. I included images from magazines, text from a Spanish
novel, papel picados, wallpaper roses and my own cutout* calaveras *face
for the model. Using "practice paintings" as underpaintings for collage
pieces frees you up to experiment and is a lot of fun.*

Loose Expressive LANDSCAPE PAINTING

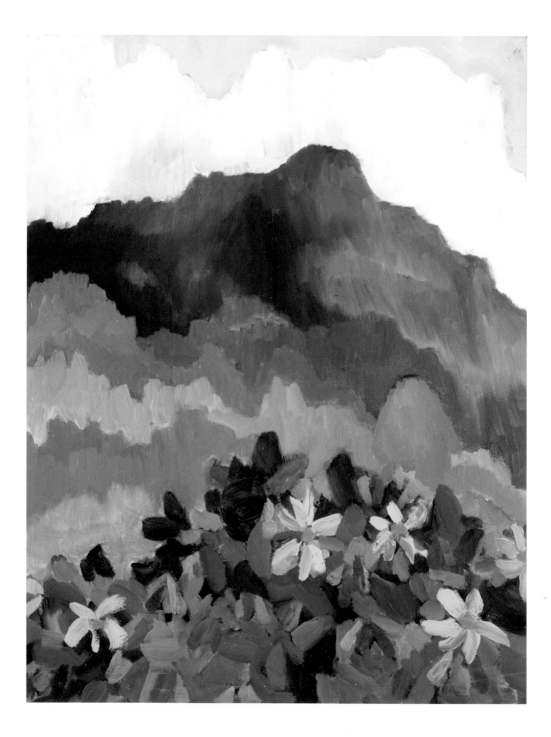

Sign up for our free newsletter at www.CreateMixedMedia.com

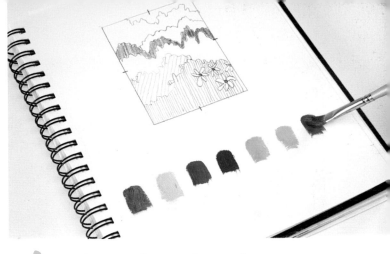

This landscape painting project can be done from life (en plein air) or from a photo or a combination of both. The challenge is to create a nontraditional landscape painting through expressive use of color and composition.

Decide on the mood or emotion you want to convey in one word, for example, *peace*, *tranquility* or *wonder*. Write this down in your Painting Notes and keep it in mind as you paint.

1 Study your reference photo and create three quick pencil thumbnail sketches in your Painting Notes of compositions using three values. Decide on an analogous/complementary color scheme.

What You Need

- bristle or synthetic bright brushes, ½" (13mm), 1" (25mm), 2" (51mm)
- drawing pencil
- paint: acrylic or oil paint in analogous/complementary color scheme plus Titanium White
- Painting Notes sketchbook
- paper towels or rags
- pencil
- reference photo
- canvas or panel, 11" × 14" (28cm × 36cm) or larger
- water container (acrylic) or Gamsol (oil) odorless solvent

2 Prepare the canvas or panel by underpainting with a bold, transparent, warm paint color.

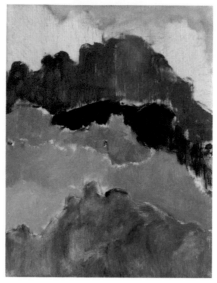

3 Sketch a very loose map of the composition on the support using the underpainting color full strength. As you design the composition from your thumbnail sketches, remember the composition cues and think about where you want to place the following: horizon line, centers, foreground/ middle ground/ background.

4 Block in large shapes using thin paint in darker values of your color scheme. Think large areas of flat color and invent color intuitively. Don't mix white with any colors yet and keep the colors transparent.

5 Layer in thicker paint, paying attention to value and color contrast as well as shapes of objects. Add the darkest areas first, then proceed to the lightest areas and last to the middle values.

6 Begin adding more definition starting from the top and working down the painting. If you are adding light clouds, save those for last and use a very clean brush and mixture of paint.

7 Add more detail to the foreground while keeping the background simple.

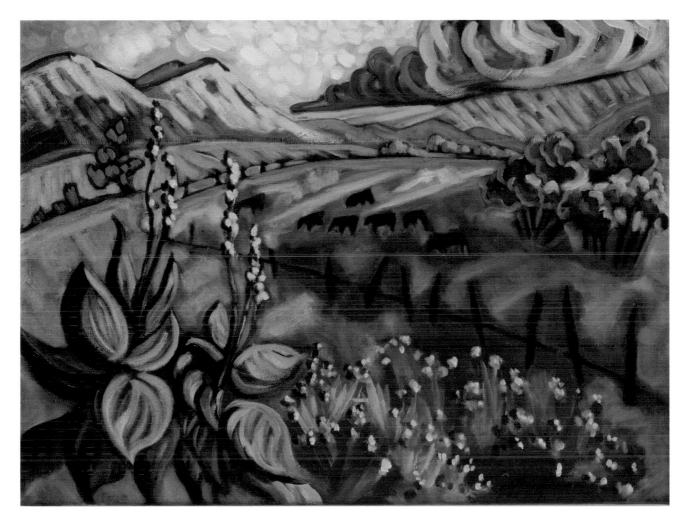

Taos Mountain

This painting was actually painted on location in Taos, New Mexico, so I suppose it can be called a plein air painting although I used my own vision of color and shapes. Remember, no one can actually tell you how you have to paint—paint your own vision.

Final Thoughts

Sign on to a process and see where it takes you. You don't have to invent the wheel every day.

—*Chuck Close*

Remember—Hand, Eye, Heart

At the start of this journey I proposed that the ingredients necessary to develop as a painter and to communicate your unique style are "hand, eye and heart," which translates to "skill, vision and passion." If you feel the *passion* to create, you must develop a plan to gain the *skill* you need to give life to your *vision*. Make a "no excuses/more time at the easel" commitment. It's important to stay process-focused rather than outcome-focused. Paint often and a lot—rather than spending six months perfecting one painting, do one a day or one a week. Don't judge your work, but instead critique it. Learn from each piece and move on to the next. Trust the process, use your critical analysis and focus, and you will learn from each painting, you will improve and you will develop your own style. And always remember, art doesn't have rules—that's the beauty of it.

- It takes time and focused hard work to learn to paint. No one could play a symphony without practicing hours of scales. The only way to improve is lots of time painting. It's a formula solution and it works.
- If you do the time, you *will* get better and people *will* take notice.

- Your rate of progress in painting is directly proportional to the time and effort you put into it—not a gift you were given at birth.
- If you're not making mistakes, you're not painting enough.
- Enjoy the process. The most frustrating day of painting should still be the best thing you could choose to do with your time.
- Don't worry about creating a signature style. It will happen when you paint enough—it's like handwriting.
- There are no born artists; everyone is creative.
- There are few original creations that don't owe something to a previous artist.
- Comparing yourself to other artists is destructive to your development; compare yourself only to yourself.
- Feedback from well-meaning family members either positive or negative is probably not helpful—too much history.
- We all learn by different methods—there is no single answer; find what works for you.
- All art is subjective; some will love your work, some will hate it, some will walk by it.

Critiquing Your Own Work

Make glorious, amazing mistakes. Make mistakes nobody's ever made before.

—Neil Gaiman commencement speech,
Philadelphia University of the Arts, 2013

We all need to learn to critique our own work as objectively as possible. The more you cast a critical eye on your work, the easier it will become to see what it needs. Pay special attention to your first thoughts when you look at a "finished" work—there's usually a message there that you need to listen to. It helps to leave a piece for a bit and come back to it, especially if it's late in the day or you are tired. You will be much more objective if you come back to it when your mind and your eyes are fresh. Here are some tricks to help you to critique your own work.

- Use the "across the room test." Hang it up, walk way across the room, turn around and pay attention to your first response: Does it excite you? Is it boring? Does some little unintended glitch grab your eye? Is that something you want to fix?
- Before you radically alter it, put it away and come back and look at it in a week.
- Take a photo of the painting and look at it on the computer—problems will jump out at you. Try looking at it in black-and-white mode to check values.
- Use a mirror to look at your painting in reverse. Weird compositional problems may jump out.
- Turn the painting upside down; does the composition still read?
- View it outside. No matter how good your studio lighting may be, colors will look different outside.

Critiquing Elements of Your Painting

- Lines: Are lines in the painting saying what you want? Could you add lines to enhance the message?
- Shapes: Are the shapes interesting? Is there variation in shapes and the spaces in between? Is there an uneven number of shapes?
- Texture: Is texture or lack of it saying what you want to say in the painting?
- Value: When you squint at the painting, does it read as all middle values (everything is one big blob)? Could greater contrast in values enhance the power of the painting?
- Color: Do color choices relate well to each other? Could more or less vibrancy of color add something?
- Positive/Negative Space: Are the positive and negative spaces varied and interesting?
- Composition: Is the overall composition interesting?

Critiquing Design Principles of Your Painting

- Unity: Do the design elements work in harmony to create a whole? Or does the piece look like it was painted by several people?
- Pattern: Do the symbols or elements in the design work or look too arbitrary? Would more or fewer elements be better?
- Rhythm and Movement: Does the composition lead your eye through the painting? Does it have a rhythm to it?
- Balance: Does the composition convey a sense of equilibrium? Or is it out of balance?
- Proportion and Scale: Are the proportions and scale of objects in the painting working for you?
- Emphasis: Where is the emphasis in the painting and is that what you intended?

Inspiration Resources

BOOKS

Albert, Greg. ***The Simple Secret to Better Painting***, North Light Books, 2003

Brommer, Gerald. ***Collage Techniques***, Watson-Guptill, 1994

Gladwell, Malcolm. ***Outliers***, Back Bay Books, 2011

Jenny, Tonia, editor. ***Incite***, North Light Books, 2013

Jenny, Tonia, editor. ***Incite 2***, North Light Books, 2014

Jenny, Tonia, editor. ***Incite 3***, North Light Books, 2015

Kleon, Austin. ***Steal Like an Artist***, Workman Publishing, 2012

Kleon, Austin. ***Show Your Work***, Workman Publishing, 2014

Lamott, Anne. ***Bird by Bird***, Anchor, 1995

MacPherson, Kevin. ***Fill Your Oil Paintings with Light & Color***, North Light Books, 2000

McMurry, Vicki. ***Mastering Color***, North Light Books, 2006

Quiller, Stephen. ***Painter's Guide to Color***, Watson-Guptill, 1999

Reyner, Nancy. ***Acrylic Revolution***, North Light Books, 2007

Sarback, Susan. ***Capturing Radiant Light & Color in Oils and Soft Pastels***. North Light Books, 2007

WEBSITES/BLOGS/VIDEOS

Artists Daily artistsdaily.com

Catherine Kehoe powersofobservation.com

Cold Wax/Oil Painting coldwaxpainting.com

Elizabeth Gilbert TED talk ted.com/talks/elizabeth_gilbert_success_failure_and_the_drive_to_keep_creating

Gelli Arts gelliarts.com

New York Public Library Picture Collection digital.nypl.org/mmpco

Turner, J.M.W. tate.org.uk/context-comment/articles/turners-radical-square-canvases-together-first-time

Vincent van Gogh, *The Flowering Orchard*, 1888.

APPS

ColorSchemer

ColorViewFinder

ValueViewer

AccuView

Paper 53

Brushes (David Hockney uses this!)

EXPRESSIVE PAINTERS I LOVE

Georgia O'Keeffe

Henri Matisse

Gustav Klimt

Vincent van Gogh

Milton Avery

Pierre Bonnard

David Hockney

Anne Redpath

Mary Fedden

Andre Derain

Maurice de Vlaminck

Paul Klee

Gabrielle Münter

 Sign up for our free newsletter at www.CreateMixedMedia.com

Index

abstract oil painting, 96–99

acrylic paints, 84, 104–5, 131

analogous colors, 40, 52, 53, 59, 131

artist ancestors, 20–21

background, 114, 124, 127, 136

balance, 12, 30, 139

collage, 88–91
 landscape, 130–33
 materials, 76–81

color, 11, 29, 34–41, 139
 balancing with neutrals, 54–55
 mixing chart, 48–49
 mixing greens, 56–57
 temperature, 12, 36
 terminology, 41

color scheme, 34, 40–41, 52–53, 58–59, 62, 136

color wheel, 36, 38–39, 50–51

complementary colors, 40, 52, 53, 54, 55

composition, 29, 30–33, 46–47, 136, 139
 landscapes, 124–27

contrast, 12, 30, 42, 43, 44, 47, 114, 115

cool colors, 36, 48–49, 54, 128

design principles, 10, 12, 139

dimension, 62

elements of art, 10, 11, 139

emphasis, 12, 139

floral still-life painting, 106–21

focal point, 30, 33

foreground, 124, 127, 136

Gelli Plate printing, 72–75, 79–81

graying down technique, 54

greens, 56–57, 60–63

grid painting, 58–59

horizon line, 11, 124, 126, 131, 136

hue, 34, 52

inspiration, 14–27, 108

Inspiration Board, 16–17

interest, 14, 54, 110, 124, 131

intuitive painting, 72, 100–103

landscapes, 32, 122–37
 collage painting, 130–33
 composition, 124–27
 painting project, 134–37

lines, 11, 139

mark-making, 66–67, 85, 94, 95, 97, 98, 99, 119

masks, 71, 95

materials, 6–7

middle ground, 124, 127, 136

monoprinting, 72–75

movement, 12, 139

mud colors, 54

negative shape painting, 114–15

neutral colors, 54–55

Notan drawing, 42–43

oil paints, 84, 96–99

Painting Notes sketchbook, 18–19, 46, 105, 108, 135

palette, choosing, 34, 36–39

passion, 8, 34, 138

perspective, 32

primary colors, 11, 34, 36, 50, 51, 54, 55

proportion, 12, 139

rhythm, 12, 139

rule of thirds, 30, 46

scale, 12, 30, 139

secondary colors, 11, 34, 36, 50, 51, 54, 55

shape of painting, 30, 46

shapes, 11, 139

skill, 8, 138

space, 11, 139

square format landscape painting, 124, 126

stamps, 68–69, 94

stencils, 70, 85, 94, 95, 119

still life paintings
 collage study, 88–91
 with creative green mixtures, 60–63
 florals, 106–21
 mixed-media, 92–95
 mixed-media floral, 116–21
 personalizing, 109

stimulation, visual, 16

style, personal, 14, 20, 138

symbols, personal, 24–27

temperature, color, 12, 36

tertiary colors, 11, 34

texture, 11, 73, 86, 89, 95, 98, 110–13, 117, 118, 119, 131, 139

three-value scale, 44–45

two-value sketch, 42–43

underpainting, 61, 84–87, 93, 135

unity, 12, 139

upcycled acrylic painting, 104–5

value, 11, 12, 29, 46, 62, 94, 115, 139
 contrast, 42, 43, 47, 62

value scales, 42–43, 44–45

variation, 30, 46, 94

variety, 89

vertical format landscape painting, 124, 126, 127

vision, 8, 138

warm colors, 36, 48–49, 54, 128, 135

wax, 97, 99

Dedication

This book is dedicated to my very special family scattered all over the country and especially to my husband, Thomas Gonzales, who is always there for me, knows how to do just about anything and always says just the right thing. I am blessed to have all of these wonderful people in my corner supporting me all the way.

Bold Expressive Painting. Copyright © 2015 by Annie O'Brien Gonzales. Manufactured in China. All rights reserved. No part of this book may be reproduced in any form or by any electronic or mechanical means including information storage and retrieval systems without permission in writing from the publisher, except by a reviewer who may quote brief passages in a review. Published by North Light Books, an imprint of F+W Media, Inc., 10151 Carver Road, Suite 200, Blue Ash, Ohio, 45242. (800) 289-0963. First Edition.

Other fine North Light Books are available from your favorite bookstore, art supply store or online supplier. Visit our website at fwmedia.com.

19 18 17 16 15 5 4 3 2 1

fw a content + ecommerce company

DISTRIBUTED IN CANADA BY FRASER DIRECT
100 Armstrong Avenue
Georgetown, ON, Canada L7G 5S4
Tel: (905) 877-4411

DISTRIBUTED IN THE U.K. AND EUROPE
BY F&W MEDIA INTERNATIONAL LTD
Brunel House, Forde Close, Newton Abbot, TQ12 4PU, UK
Tel: (+44) 1626 323200, Fax: (+44) 1626 323319
Email: enquiries@fwmedia.com

DISTRIBUTED IN AUSTRALIA BY CAPRICORN LINK
P.O. Box 704, S. Windsor NSW, 2756 Australia
Tel: (02) 4560-1600; Fax: (02) 4577 5288
Email: books@capricornlink.com.au

ISBN 13: 978-1-4403-3860-1

Edited by Tonia Jenny
Photography by Christine Polomsky and by
Kristi Johnson Photography,
www.kristijohnsonphotography.com
Designed by Jamie DeAnne
Production coordinated by Jennifer Bass

Acknowledgments

Thank you to Tonia Jenny, acquisitions editor and senior content developer, North Light Mixed Media, for her editorial expertise and guidance in the development of this book. Without Tonia this book would never have happened; thank you so much for helping me realize a dream. Another big thank you to the supportive on-site team of Beth Erikson, Brittany VanSnepson, and Christine Polomsky who patiently walked me through my first-ever photo session—they are true professionals and a lot of fun! Another thank you to Amy Jones, whose encouragement got me through my first video session—you made painting on camera fun. The professionals at F+W Media have been a joy to work with and I truly appreciate their efforts.

A special thank you to Kristi Johnson of Kristi Johnson Photography, www.kristijohnsonphotography.com, for the lovely shots of my studio and the great margaritas afterwards!

Metric Conversion Chart		
To convert	*to*	*multiply by*
Inches	Centimeters	2.54
Centimeters	Inches	0.4
Feet	Centimeters	30.5
Centimeters	Feet	0.03
Yards	Meters	0.9
Meters	Yards	1.1

About Annie

Annie O'Brien Gonzales is a professional painter, teacher and writer in Santa Fe, New Mexico. In her studio on Canyon Road, she creates colorful and expressive floral, still-life and landscape paintings. She paints intuitively with inspiration from nature combined with personal symbols and patterns.

Her work is represented by galleries across the U.S., has been shown in numerous juried art shows, collected by art lovers across the U.S. and recently was included in a museum permanent collection. She is also a docent at the Georgia O'Keeffe Museum and a tour guide at Ghost Ranch in Abiquiu, New Mexico. She teaches painting workshops in her studio in Santa Fe and across the country as well as at Ghost Ranch and at the Georgia O'Keeffe Museum.

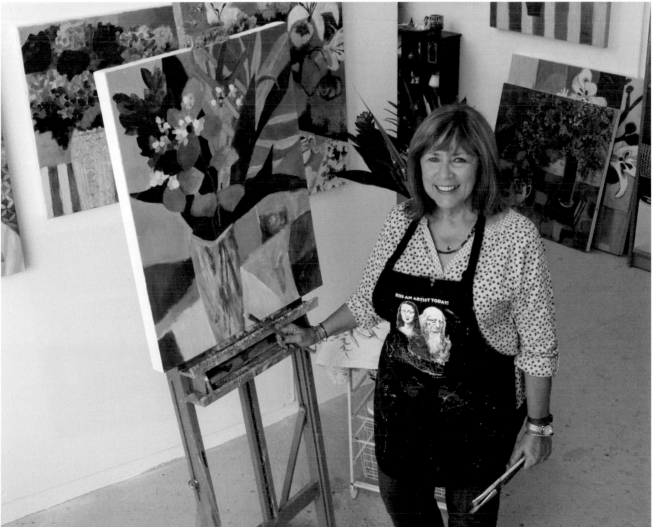

Ideas. Instruction. Inspiration.

Receive FREE downloadable bonus materials when you sign up for our free newsletter at CreateMixedMedia.com.

Find the latest issues of Cloth Paper Scissors on newsstands, or visit shop.clothpaperscissors.com.

These and other fine North Light products are available at your favorite art & craft retailer, bookstore or online supplier. Visit our websites at artistsnetwork.com and artistsnetwork.tv.

Follow CreateMixedMedia.com for the latest news, free wallpapers, free demos and chances to win FREE BOOKS!

Get your art in print!

Visit **CreateMixedMedia.com** for up-to-date information on *Incite* and other North Light competitions.